Oil-painting
Workshop II

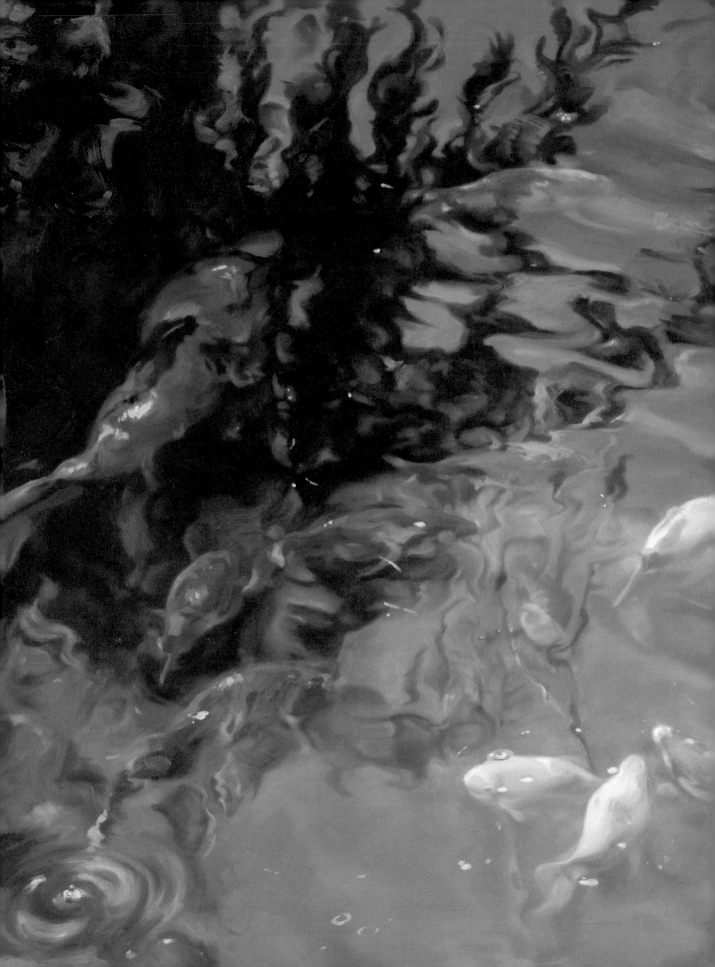

Oil-painting
Workshop II

Rachel Lockwood

DK Publishing

LONDON, NEW YORK, MELBOURNE,
MUNICH, AND DELHI

Project Editor Kathryn Wilkinson
Managing Editor Julie Oughton
Managing Art Editor Christine Keilty
Production Editor Sonia Pati
Production Controller Rita Sinha
US Editor Margaret Parrish

**Produced for Dorling Kindersley by
Cobaltid**

Editors
Marek Walisiewicz, Sarah Tomley

Art Editors
Paul Reid, Rebecca Johns

First American Edition, 2008
Published in the United States by
DK Publishing
375 Hudson Street
New York, New York 10014

08 09 10 11 10 9 8 7 6 5 4 3 2 1

OD040—May 2008
Copyright © 2008 Dorling Kindersley Limited
All rights reserved

Published in Great Britain by Dorling Kindersley Limited.

A catalog record for this book is available
from the Library of Congress.

ISBN 978-0-7566-3676-0

DK books are available at special discounts when purchased
in bulk for sales promotions, premiums, fund-raising, or
educational use. For details, contact: DK Publishing Special
Markets, 375 Hudson Street, New York, New York 10014 or
SpecialSales@dk.com.

Printed and bound in China by
Hung Hing Offset Printing Company Ltd.

Discover more at
www.dk.com

Contents

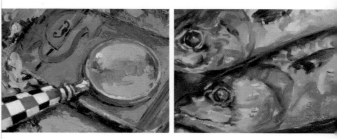

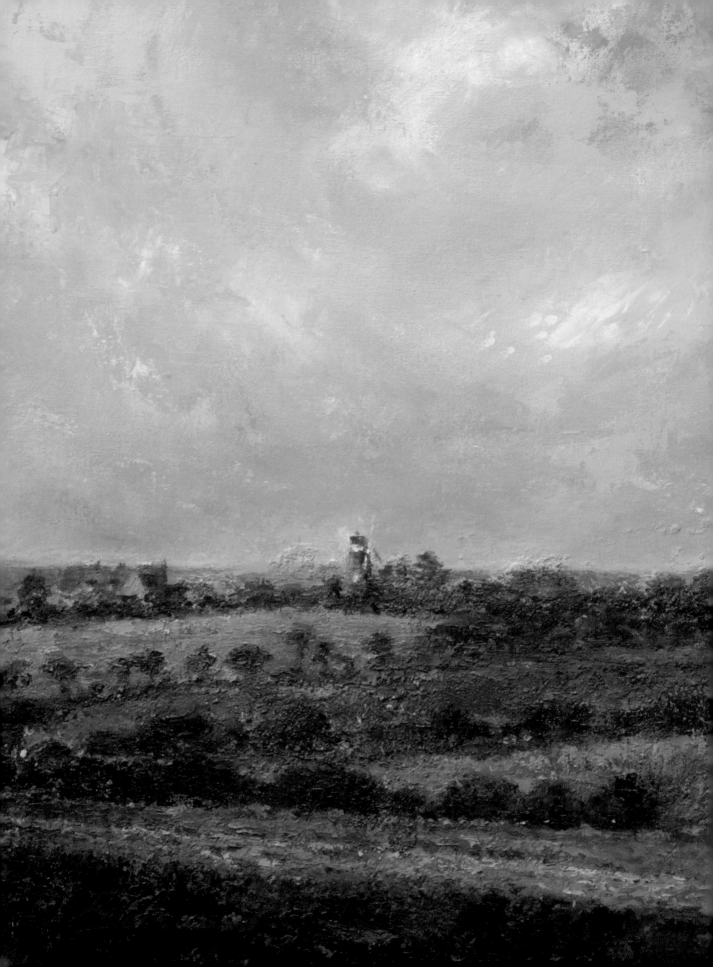

Introduction

Oil paints are the paints of the Old Masters, and the qualities of the paints are intrinsic to these wondrous works. The rich, buttery texture, the vibrant colors, and the sheer maneuverability of oils means there is no scene or subject that is beyond expression. The fluidity of the paints, the easy way in which they interact, and their slow drying times make them perhaps the easiest of all mediums, especially for artists experimenting with style and technique. Everything you paint can easily be nudged from one color, tone, or shape into another until you begin to achieve exactly the effect you are seeking. Oils give your paintings an instant richness of color, with a sculptural quality that offers a myriad of textural effects. These forgiving paints are the perfect tool for exploring representation and expression.

Improving your skills

In this book you will learn how to build upon your oil-painting skills, to give you a broader range of approaches and to help you achieve more satisfying results. We start by taking a fresh look at the tools, materials, and paints you are using to introduce you to new or more advanced possibilities. You may want to work against a background color, for instance, to better judge your mid-tones or to create a textural effect—and we look at how this may be achieved through the use of colored grounds or unpainted, more unusual supports. We explore the strengths of different brushes for different tasks and look at working with knives and other implements, which hugely increases the textural potential of your paintings. The first part of the book includes a quick reference section on basic techniques, which will be put into practice during the projects. You can then expand your range of skills through the more advanced techniques introduced in the 12 self-contained, step-by-step projects. The addition of these skills will liberate you as an artist—the more techniques you are able to call upon, the less concerned you need be about making mistakes, and the bolder your work can become.

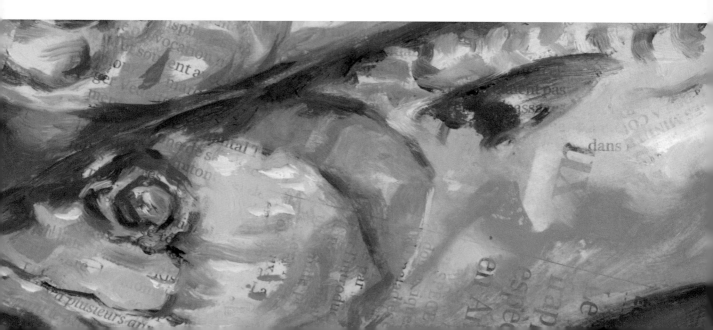

Finding your strengths

The projects in this book are based around four subject areas: still life, landscape, life and portrait, and contemporary practices. Each one presents a different set of challenges to the artist, calling upon a certain kind of observation—close or distant, detached or personal—which must then be translated into an image on the canvas. The projects ask you to experiment not only with new skills and techniques, but also to broaden the way in which you see the world, and select your subject. No two artists would ever stand in front of a subject—be it a landscape or person—and paint them in an identical way; the differences would always be enormous. These differences lie not in the techniques alone, but in a series of judgements, and this book aims to give you all the information you need to make better choices from a wider selection of options. The step-by-step projects in each section explore the ways of seeing and describing your subject, and this is pushed into an exciting, experimental area in the chapter on contemporary practices. Whatever your subject—people, animals, flowers, or landscapes—this book will help you develop a more personal, individual style.

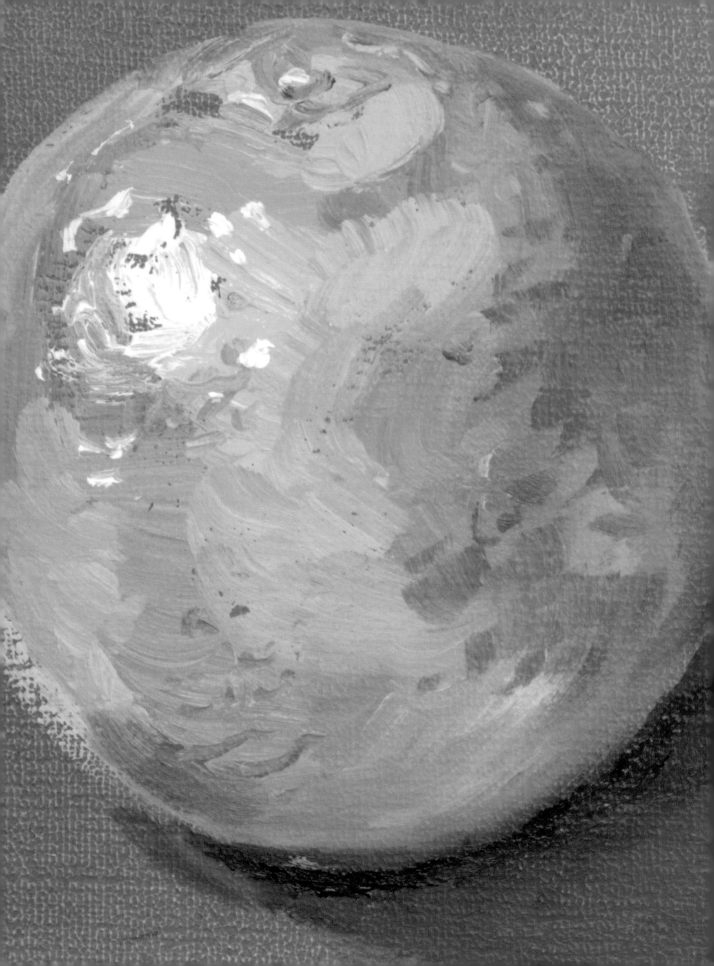

Materials

Your choice of painting materials will depend on many factors—the quality and surface texture of the desired finish, the effects you are aiming to achieve, and, of course, cost. When developing your work, inexpensive paints and nondurable substrates give you the freedom to experiment, but more costly materials generally provide greater permanence and density of color for finished pieces. Many products—some traditional, some new—allow you to modify the characteristics of both paint and substrate.

PAINT

There is now a vast range of paints available, from traditional oils—in student and artist ranges—to water-mixable oils and alkyds. In essence, all these paints are a combination of pigment (providing color), and some kind of binder (such as linseed oil), which gives oil paint its distinctive buttery consistency. The binder used dictates the drying time, while the amount and quality of pigment used controls the density of color.

Students' oils These typically contain synthetic pigments in relatively low quantities, so are less vibrant than traditional oils. Touch dry in 2—12 days; approximately 50 colors.

Artists' oils These top-quality paints have a high pigment content and a buttery consistency. Touch dry in 2—12 days; approximately 120 colors.

Alkyd oils These resin-based paints are more fluid than traditional oils and dry much faster. Touch dry in 1—24 hours; approximately 50 colors.

Water-soluble oils These paints look and work like traditional oils, but dry faster and contain no solvents. Touch dry in 2—6 days; approximately 40 colors.

BRUSHES AND STROKES

Brushes of different materials, shapes, and sizes make different types of mark. Bristle brushes handle thick paint well, whereas softer sable brushes are better for applying thinner paint for details and glazes. Synthetic brushes hold paint well, are less expensive, and make smooth marks. The number on a brush signifies the width of the paintbrush head—and the mark it will produce.

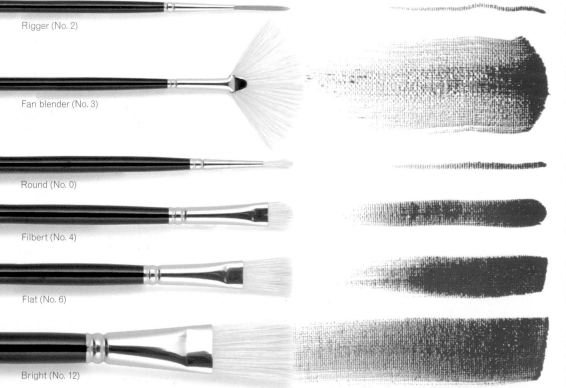

Rigger (No. 2)

Fan blender (No. 3)

Round (No. 0)

Filbert (No. 4)

Flat (No. 6)

Bright (No. 12)

Riggers are useful for painting long, thin lines and details, and for dragging lines of paint.

Fan blenders can be used to feather paint, to soften underlying brushstrokes, and for tonal gradation.

The most versatile of brushes, rounds are especially good for the soft strokes used in underpainting and detail.

The soft, tapered strokes of filberts make them good for fusing and softening edges.

Flats leave a sharp, square mark, useful for edges. The broader sizes can be used to fill large areas.

Brights have short, stiff bristles and are excellent for textural effects, such as impasto, and for visible brushmarks.

CHOOSING THE RIGHT SUPPORT

While canvas is the traditional support for oil painters, art board, Masonite/MDF, and even paper and cardboard can be used if correctly primed. Use three to five coats of gesso primer, sanding between each layer, unless you want a textured surface. Boards may warp as you apply paint to their surface; a quick remedy is to paint three layers of oil or acrylic to the reverse to straighten the substrate.

Canvas Easy to carry, fine texture; can crack in humidity.

Canvas board Surface as for canvas (*see left*) but rigid.

Masonite/MDF Rigid, flat, inexpensive surface; needs primer.

Linen canvas The most durable type of canvas (*see left*).

Oil painting paper Good for practice work; nondurable.

Canvas paper Textured paper; good when traveling.

MEDIUMS

Mediums change or enhance the characteristics of paint. They can slow down or speed up drying times, thin or thicken paint, increase or decrease gloss, or act to protect the finished work. It is also possible to grind pigment directly into oil and alkyd mediums to make your own oil paints.

Thinning mediums A simple medium of linseed or poppy oil and white spirit can be used to dilute paint, in order to increase flow, transparency, and drying time. Linseed oil mixed with turpentine or odorless thinner is most often used. If mixing your own medium, always use pure, clean, artists' grade oils and solvents.

Texture mediums The most common forms of impasto mediums available are known as Liquin and Oleopasto, which are used to bulk up the paint and increase texture within a painting.

Alkyd mediums and gels These resin-based mediums can be mixed into traditional oil paints to increase flow and transparency while speeding up the drying time. They are especially useful for achieving fast-drying glazes.

Varnishes Gloss or matte varnishes can be used over dry paint to protect the finished painting. Varnish generally takes 12—36 hours to dry, but quick-drying varnishes are also available. Retouching varnish is a specialized product that can be used to revitalize dull areas of paint.

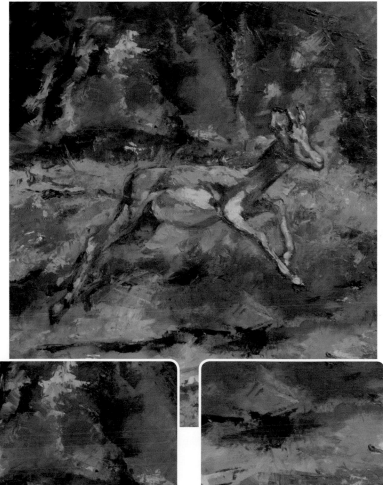

Alkyd Plasticizing agents like alkyds allow thin layers of paint to be applied over thick paint without the risk of cracking.

Linseed oil Thinning with oil retards the drying of paint, giving great latitude for mixing and blending colors.

Knives and other tools

Knives are an essential part of the oil-painter's tool kit, allowing you to mix, apply, and remove paint in more ways than with a brush. They are flexible tools that come in numerous shapes and sizes, as shown below.

A knife, or perhaps a more experimental tool such as a roller or spatula, is especially useful when you want to apply thicker layers of paint, add some rich impasto, or spread the paint widely over a surface.

KNIFE OR BRUSH?

Many artists work by alternating the brush and knife, using the brush to outline shape and create complex forms, and the knife to create texture and multiple planes. This process can also be reversed – you can use a broad knife to apply a flat area of paint, and then apply texture or detail through the use of a brush. The tip of a pointed knife can also be used to add detail or to remove paint from a surface, which is invaluable if you wish to make any changes to your painting.

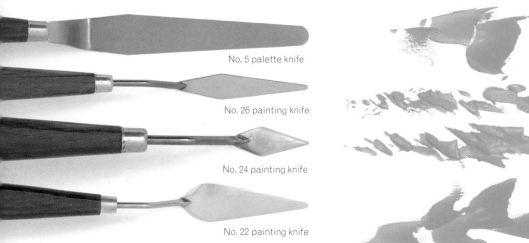

No. 5 palette knife

No. 26 painting knife

No. 24 painting knife

No. 22 painting knife

Knives In strict terms, a palette knife (*top*) is used for mixing paint on the palette, while a painting knife, which has a more flexible blade and a distinct kink in its handle, is used for mark making. In practice, most artists use, and refer to, the two interchangeably. Like brushes, knives come in a wide range of shapes and sizes, some with acute angles for sharp details, others more rounded.

PAINTING WITH KNIVES

You can apply paint with any part of a knife, from its metal tip (flat or side-on) to the heel of the handle. While you have less control than when using a brush, knives produce exciting results. Popular techniques for painting with a knife include impasto – to lay on thick paint; sgraffito – where the sharp point of a knife is used to scratch through to a lower layer of paint; and pointillism – where tiny dots of colour are applied to the surface using the tip of the knife.

Large areas You can use a knife in a trowel-type motion, like plastering a wall, to make flat areas of colour. Load a large or small amount of paint on to the knife and then pull it across the substrate.

Thin lines The side edge of the knife blade is good for painting lines, especially horizons. Dip the side edge into the paint and drag the knife along the support in the direction of the desired line.

Textural effects You can achieve an interesting effect by loading the flat body of the knife with paint and pressing it flat against the support, before lifting it off again. This is useful for painting flowers.

ADVANCED TOOLS

You can use knives to mix in more unusual elements, such as sand, plaster, or woodchips to create more textural effects in your paintings. The number of different marks you can make is almost limitless, especially if you employ other tools, such as rags, rollers, glue spreaders, and brush ends or sticks to work your paint. Artists often develop unique personal styles through experimentation, if only to return ultimately to the simplest of tools.

Rags can be used to rub paint on to the support. Wrap one around your finger, dip it into the paint and use it like a pen to produce crisp or blended edges.

Rollers are a useful alternative when you want to cover large areas of the support. Paint can be applied thickly or thinned down with a suitable medium.

STIRRING SURFACES

With its buttery consistency and prolonged drying time, oil paint is the ideal medium for holding texture. Many different surface effects can be created with knives or brushes – for example, brushmarks of consistent weight and orientation can be used to unite elements, such as disparate colours in land and sky, or to define outlines of objects. When planning a painting, consider what role these marks should play and never treat them as mere embellishments to the colours.

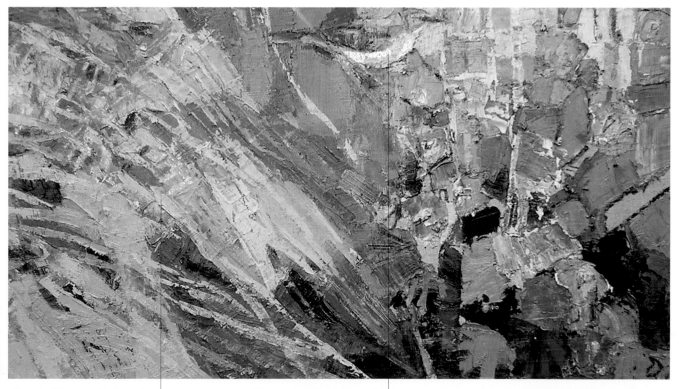

The mix of brush and knife work in this area creates both crisp-edged grasses and softer stems that suggest flexibility and movement.

The curves of this bird are quite different to everything else in this painting. Its body was outlined with a brush, then painted using a knife.

Contrasting textural effects have been created here using a combination of broader, flat areas of paint with thin, sharper lines.

Working with paint

As you become a more practiced artist, start thinking about ways in which to stretch your technical skills and your manipulation of the paint, through the use of unusual tools, different mediums, or paint types.

Consider trying new treatments for your surfaces: a smoother surface is easier for highly detailed work, while a colored ground (*see right*) enables you to choose and judge color values more accurately.

MIXING YOUR PAINTS

Paints can be mixed on a palette using a knife or brush, or on the support itself. A palette allows you to mix colors and return to them later, modifying their color or texture as required. Colors can be blended to a smooth, consistent hue, or roughly for deliberate streakiness. One trick is to "pick up" two or more colors from the palette and apply them to the support (*see right*).

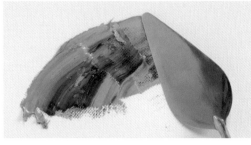

Mixing on the support
Applying two colors with a knife "squashes" them on to the surface, blending the two colors in a very distinctive way.

FAT OVER LEAN

As your paintings become more layered, you will need to pay particular attention to the "fat over lean" rule. This rule states that you should always paint "fatter" paint over "thinner" paint, to avoid causing cracks in the surface of the painting as it dries. "Fat" paint contains a higher percentage of oil, while "thin" paint is one that has been thinned using only turpentine or a very small amount of oil. Use thinner paint for painting your initial layers, and thicken your paint with each layer that you add.

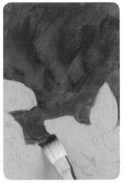

Underpainting Always thin out your paints with turpentine for painting your first layer. Some of this will be absorbed by the surface of your support.

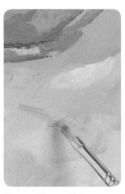

Second layer Thicken your paint for your second layer, to the consistency of a thin cooking sauce. This layer smooths the surface as you paint.

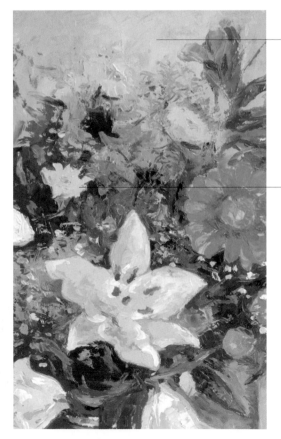

The background was painted on as the second layer. While the paint for this layer is necessarily thin, you can still add texture by not overblending your colors.

The rich texture of thick impasto paint here really helps these smaller flowers to stand out.

Building up layers
The extraordinary depth of oil paintings relies on a careful building up of layers. The red underpainting in this picture is still visible behind the flowers, lending warmth to the whole painting.

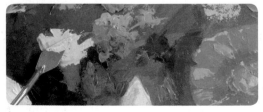

Upper layers Thicken the paint as you go, adding final details in very thick paint if you wish. These marks will take much longer to dry than the ones in the earlier layers.

USING A COLORED GROUND

Many artists like to color their surfaces before starting on a painting rather than working on a white background. Such colored grounds, usually painted in neutral or midtones, are useful because they help you judge relative color more accurately (*see below*). Colored grounds can also help establish mood and unite disparate colors used in the work. Alkyds are often used for applying colored grounds, because they dry rapidly.

White background Objects can look strangely weightless against a white background. All colors contrast strongly against white, so you will find that a white background encourages the use of paler, softer colors.

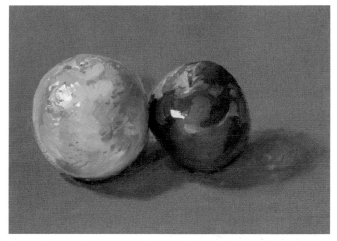

Colored/neutral background A colored background allows you to judge values more accurately, and seems to ground objects more effectively. It can also lend the artist confidence, encouraging a bolder use of color.

TRANSLUCENCY

Oils are the perfect medium for achieving glossy layers suggestive of watery translucency. Add glazing medium or pure oils to your paints to build up glassy layers like those shown here.

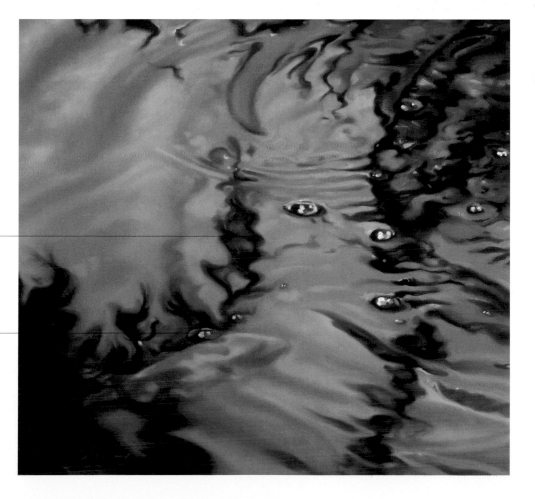

The shadows reflect the movement of the water and give the painting (and water) more depth.

Highlights create glasslike bubbles on the surface.

Transparent layers
The water element of this picture was painted by blending layers of light and dark blue glaze—with added oils—to create a smooth, vibrant surface.

Developing color

Artists work with particular color palettes to enhance the atmospheric and emotional impact of their work. Although a subject might seem to dictate the predominating color range, you could choose to work in an entirely different set of colors—which still match the intensity and tones of your subject. Try experimenting with warm and cool colors, or darker and brighter ones, as shown below.

USING A DARK PALETTE

The dark range is a calmer palette, which ranges from relaxing to melancholy. Dark colors absorb the light, rather than reflecting it, like natural elements on a gray, wintery day. This has the effect of drawing in the viewer—inviting them to search within the painting's hidden depths. Paintings using dark palettes feel older and wiser: the colors are more natural, and have an earthy integrity. The colors shown here form a good starting point for a darker palette. Try mixing in Naples yellow, flesh tint, yellow ocher or white for lighter tones and highlights.

USING A BRIGHT PALETTE

The bright range reflects light, bouncing it back to the viewer like objects on a bright summer day. These colors are almost artificially bright, and artists have exploited this man-made quality to lend paintings an instantly contemporary effect. Psychologically the brighter colors are said to represent emotions from contentment and comfort to passion. They can be mixed to more subtle tones for a gentler mood, or used straight from the tube to add focus and vitality. Use the blues and browns to "muddy" tones and take the edge off the colors' inherent intensity.

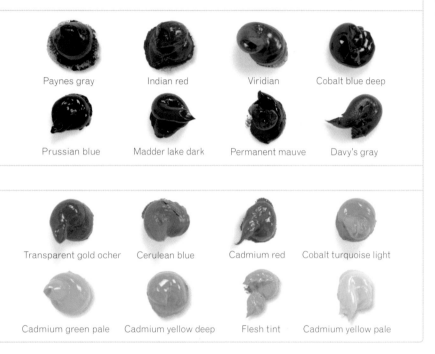

Paynes gray Indian red Viridian Cobalt blue deep

Prussian blue Madder lake dark Permanent mauve Davy's gray

Transparent gold ocher Cerulean blue Cadmium red Cobalt turquoise light

Cadmium green pale Cadmium yellow deep Flesh tint Cadmium yellow pale

MIXING NEUTRALS

Neutral colors are a range of browns and grays that have subtle, natural tones and low intensity. They are gentle but surprisingly rich colors, that will add depth to your work. The richest neutrals are obtained by mixing complementary colors together. If you then add white, a range known as "broken colors" is obtained, which can steer toward a warmer or cooler palette.

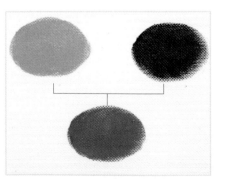

Yellow/purple Naples yellow deep and permanent mauve mix together to form a soft neutral which is useful for flesh tones. You can make it darker and cooler by increasing the proportion of mauve.

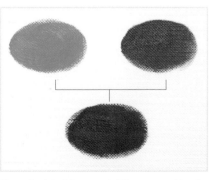

Green/red In this example Winsor emerald and cadmium red middle were mixed to achieve a rich, chocolatey neutral. A red-green mixture will always give you the warmest base for a neutral.

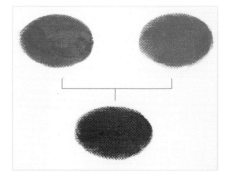

Blue/orange Cerulean blue and chrome orange tone were mixed together here for a cooler, darker neutral that is useful for painting shadows and shaded areas, especially in landscapes.

COLOR AS THE MAIN FEATURE

Artists have long argued about whether form or color is more important in a painting. Color can be used to add detail, focus, and atmosphere, or as a compositional device. Or it can become virtually the whole story, where the impact of the painting rests almost entirely on the colors, with little reference to form. Many abstract painters, such as the colorist Howard Hodgkin, achieve incredible expression through color alone.

The understated approach to color in this picture feels almost hesitant, echoing the tentative steps of the wading bird. The colors are those of the landscape in winter, when the skies are overcast, and the light an even, dull gray.

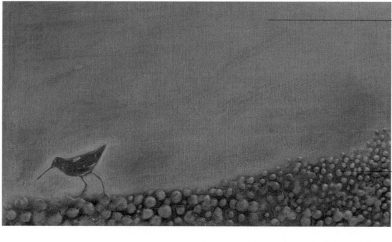

Many layers of subtle color have added a discreet depth.

A contrast in texture adds interest to a picture using a limited palette.

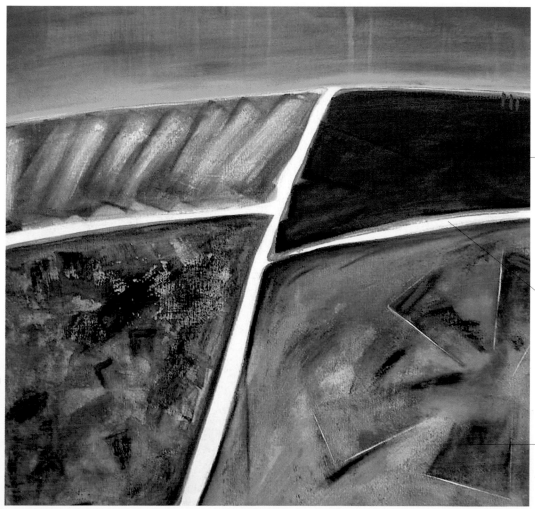

The vibrant colors and strong patterns of this picture were inspired by the artist's love of the countryside. They express a simple joy and a great feeling of space.

The boldness of color is balanced by a carefully judged loss of detail.

The starkly contrasting pathway through the blocks of color leads the eye and takes us on a journey through the painting.

The series of shapes in this corner represent a windmill. Red has been chosen to highlight areas catching the light as the blades move.

Essential techniques

There are many different ways of applying paint to a support, each of which affects the final painting in a distinct way. By increasing your range of techniques you will broaden both what you can paint, and how.

You can also afford to become more relaxed as you paint: color and shapes do not have to be perfect first time if you know how to soften edges, "knock back" color, or add details or texture at a later stage.

IMPASTO

This technique allows you to apply thick layers of paint, retaining any brushstrokes or ridges made by the knife or brush. It adds texture to your painting in a tangible way, increasing a sense of depth.

Tools and materials: Use molding paste or an impasto medium mixed with oil paint for faster-drying textural effects; or use oil paints straight from the tube. Apply the paint or paste using a knife, stiff brush, or fingers.

Molding paste can be used to create a thick, textured underlayer to a painting. Load it on to a knife and spread it around the support until you have the thickness and ridge marks you require.

The paste can be used to achieve wide, flat areas that are raised above the painting surface, choppier patches of rough texture, fine relief lines or very small raised "splatters" of texture.

GLAZING

This technique is used to lay down thin layers of transparent paint, leaving no visible brushmarks. Glazing adds depth and luminosity to your painting, as you can build up many layers of transparent paint. It can also be used to mix colors: a glaze of blue over yellow will appear green, for instance.

Tools and materials: Use a glazing medium. Oils can be used to thin paint, but are not best for glazing purposes—they tend to run and they take too long to dry between layers. Use large, very soft brushes to apply the glaze.

Paint any layers below the glaze and wait until they are completely dry. Load a large, very smooth brush with paint that has been thinned out with glazing medium and apply as a soft wash.

Layers of smooth glazing can be built up on large areas in varying colors until you achieve a luminous background. A glaze can work in brilliant contrast to sections in thick impasto.

BLENDING

Blending is used to soften edges between colors and tones, by gently brushing between the edges of two colors until they merge.

Tools and materials: No medium is necessary, although linseed oil can be used on drier areas to work into the drying paint again in order to loosen it for blending. When choosing a tool, bear in mind that harder brushes will blend with texture (leaving brushstrokes), while softer brushes, rags, and fingers can be used to blend without visible marks.

Blend any hard edges between colors or tones using a soft brush (or your fingers) to stroke the edges where the colors join. The two colors will gently and imperceptibly merge into one another.

Use blending when you are working on areas with many tones, and wish to concentrate first on blocking in. The sharp lines between the blocks of tones will disappear when softened by blending.

DRY BRUSH

This technique is used to add a fine, light, but uneven layer of paint for a "scratchy" effect. It is especially useful for adding the impression of detail to busy foregrounds—foliage and blades of grass, for example, may be represented in this way.

Tools and materials: No medium is necessary. Choose your brush depending on the shape of the edge marks you require: flats for flat edges, fan brushes for wide arcs, and round brushes for points.

The dry brush is loaded with a small amount of paint and then dragged through the layer below as required. The technique can be performed into wet paint, blending slightly (*as above*) or dry paint.

Most of the paint is laid down at the top of the stroke, which is why your choice of brush shape— round, flat, or fan—is critical to achieving the shape of brushmark you require.

STIPPLING

This technique is a way of adding "dots" of paint: either tiny dots of color (as in pointillism) or larger dots from the tip of a brush. Stippling allows you to add small areas of paint over layers, to break up colors or add detail.

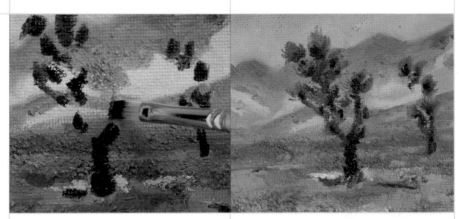

Tools and materials: No medium is necessary, but impasto medium can be used for thicker marks. Use a fine brush, knife point, or rag. Choose your brush or other tool according to the size and shape of the marks you require.

Mix the paint to the desired consistency, using impasto medium to thicken and texture the paint if necessary. Apply the paint using the tip of your brush, working in short, sharp movements.

Stippling can be used to provide contrast and depth in a painting. Here, the trees are stippled against a smooth, well-blended background, creating visual depth.

SCUMBLING

Scumbling is a way of adding a thin, uneven layer of paint over an existing layer, allowing part of the underlying layer to show through. This technique is used to knock back areas of color that you feel are too solid, too bright or too dark. It can also be used to prepare areas of a picture for repainting.

Tools and materials: No medium is necessary. Use a stiff brush or rag.

Scumbling is invaluable for making corrections to your paintings, especially if you want to make changes to a highly contrasted area that runs across the full spectrum of tones.

If you are scumbling for correction, dip a rag in some thinned paint mixed to a midtone of the area you are covering. Rub in the paint gently, until the area has an even, flat tone.

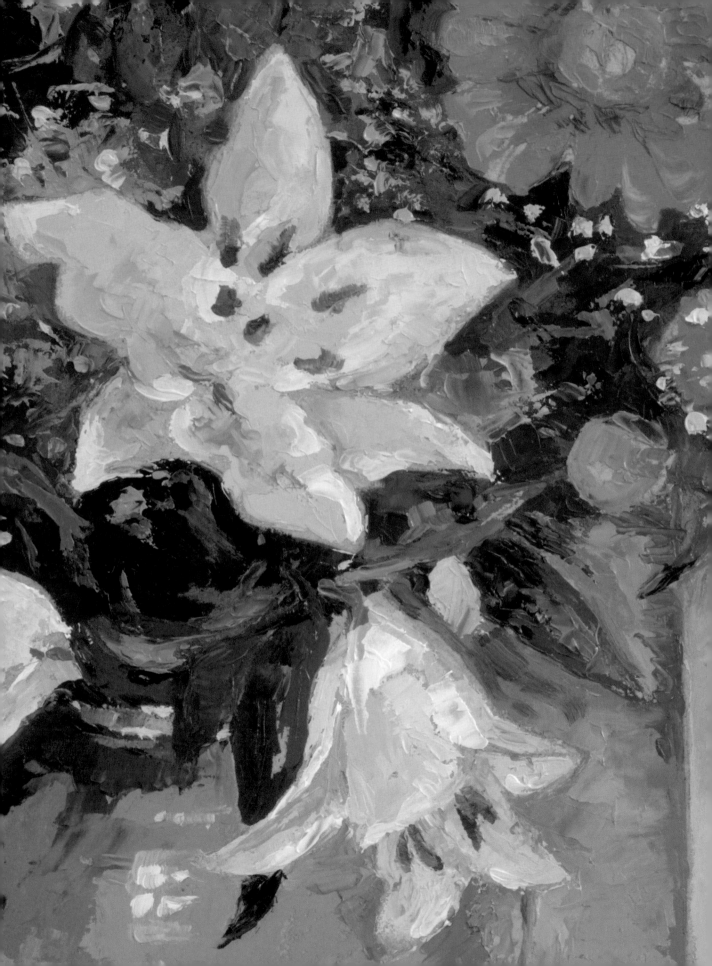

Still Life

"Painting still life
allows us to bring energy
to static objects."

Composition and focus

The art of composition lies in finding a delicate balance between what looks natural and what looks interesting. An unusual arrangement may have a natural flow; or everyday objects may be viewed from an unusual angle. Consider the elements of your painting and the space around them. Think about the unity of the painting as a whole. Use composition to draw in the eye and guide it around the painting.

A NATURAL LOOK

Many successful still life arrangements look natural, as though the artist stumbled across something that already existed. In reality, such "found" scenes are often artfully arranged and lit to provide depth, interest, and a path for the eye to follow. Compare the dynamic composition to the right, with the "found" scene below.

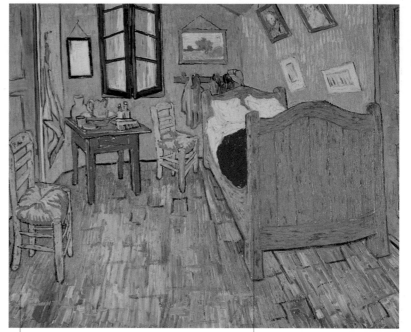

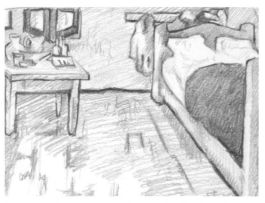

The positioning of the objects here pushes the viewer's attention to the edges of this picture. This uncomfortable composition almost excludes the viewer from the scene.

The uncluttered area at the bottom of this picture allows space for the viewer to enter.

An unusual perspective on to the bed gives depth to the room and the painting.

The Bedroom Van Gogh's unusual composition adds a sense of movement to otherwise static objects.

FLOW AND INTERACTION

Interactions and overlaps between objects and their shadows set up rhythms that contain a viewer's interest within a painting. Compare the sketch below with the more harmonious, unified painting to the right, where the eye is simply not allowed to "slip off" the canvas.

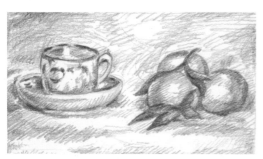

Separating the fruit from the tea cup disrupts the movement of the eye and the composition falls apart.

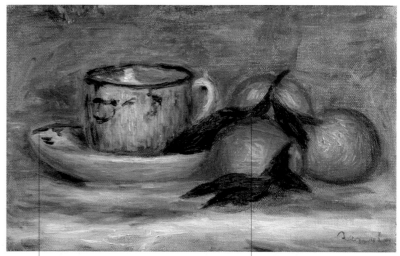

Detail here allows the eye to travel right to the edge of the saucer.

The natural shape of the leaves helps to lead the eye around the fruit and the painting.

Still Life Renoir's sensitive composition lends the objects a natural flow and interaction.

THE GOLDEN SECTION

Since the Renaissance, many artists—including Leonardo da Vinci, Piero della Francesca, and Georges Seurat are said to have based compositions on the "golden section." This term describes a line or rectangle of particular proportions—a ratio of 8 to 13—that can be used to position objects in a painting. The theory holds that any arrangement based on this magical ratio should look natural, because these proportions reflect those found in many living things, such as plant and animal bodies.

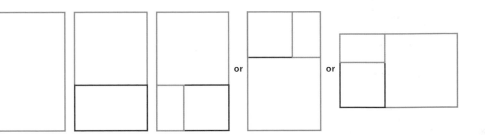

A B

The golden section of a line is a point at which the relationship of the longer section of the line to the whole line is the same as the smaller section to the larger. For example, in the line above, the ratio of AB to BC is the same as BC to AC.

C

A golden rectangle is one in which the length and the width restate the "golden" 8:13 proportions. Placing another, smaller, rectangle of the same proportions within the first, introduces another line of interest and this nested construction can be continued *ad infinitum*. To work with the golden rectangle, make a rough sketch of your subject. Choose a key plane or point and build other elements around this by constructing golden rectangles away from this "anchor." Alternatively, you can start by registering the entire canvas as a golden rectangle, and work from there to find focal lines and points for your composition.

Mona Lisa's face can be broken down into golden rectangles.

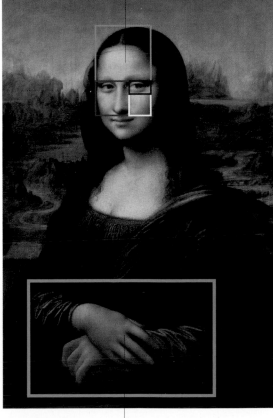

Mona Lisa Da Vinci is said to have used mathematical concepts in many of his paintings.

The sleeves and hands appear out of the darker area within a golden rectangle, which defines the height and width of their outer edges.

The large rectangle establishes the boy as the main focal point of the painting and sets the position of the horizon.

Seurat painted this boy in and out of the picture, unsure if he led the eye too strongly away from the focal point of the golden section.

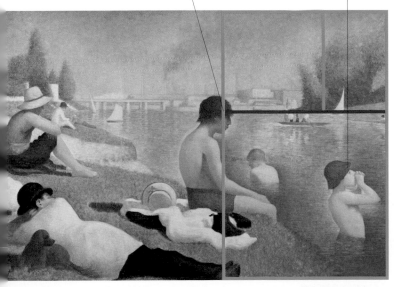

The golden proportion is close to one-third, so in many ways the golden section rule is similar to that of the rule of thirds, which states that elements of interest are best placed a third of the way into a picture. However, one of the more interesting elements of the golden section is that you can continue fitting rectangles within rectangles to govern your composition, as in the paintings by Seurat and Leonardo Da Vinci shown here (*above and right*). Seurat was said to be fascinated by the golden rule.

Une Baignade, Asnières (Bathing at Asnières) Seurat revived interest in the golden section after his detailed study of it during the nineteenth century.

Light and shade

Patterns of light and dark in a painting provide form, contrast, and atmosphere—they are the lifeblood of your painting. By mastering the use of these patterns you can successfully transform two-dimensional shapes into an effective illusion of three-dimensional objects. When judging tonal values, consider both the tones within the object itself, and the quality, intensity, and direction of your light source.

The power of contrast

Tone helps to define features and objects in a painting—perhaps even more than color or line—yet it is often overlooked. When planning a painting, it pays to think tonally; simplify the composition into five or six areas of distinct tone and consider how they interact. High contrast between adjacent areas of tone creates the impression of depth—a sense that you can almost walk through the painting—while low contrast creates a flatter, moodier result.

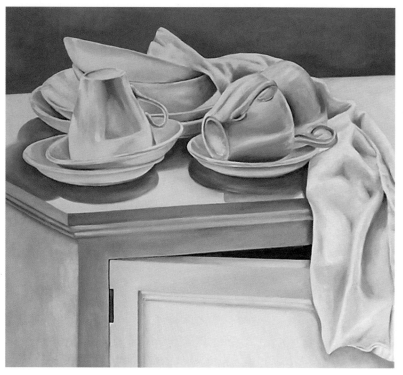

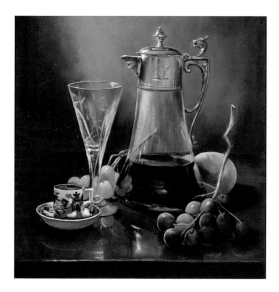

Low contrast In this painting, low contrast is used to create an unsettling atmosphere; it is a domestic scene of disarray, where everything seems fragile—almost transparent.

High contrast The range of contrast between the sunlight on the glass and silver, and the darker tones of the room and table, gives this painting almost tangible solidity and depth.

DIMENSION THROUGH TONE

In this exercise, the subject is a ball, lit from the above right. First, draw or paint a simple circle to outline the object.	Study the light on the ball. Now paint the lighter side of the ball (shown on the right above) in light tones of orange.	Mix a slightly darker orange hue, and begin to paint the darker tones leading toward the darkest shadow area to the left.	Add the darkest shadow area. You can afford to be bold here in your choice of color as this will soften when blended.	Blend together the lighter and darker tones from the top and bottom of the ball, stroking gently with a soft brush.	Add a white highlight where the light strikes the ball most directly; this completes the three-dimensional effect.

Drawing in tones

To map out areas of tone in your work, make your underdrawings in charcoal rather than pencil. This medium allows you to build, blend, erase, and reposition tones before committing to paint. For maximum depth and body, your work needs to include tonal extremes—both very light and very dark tones. Restricting the range of tones will produce a flatter, but more atmospheric effect. For example, a dramatic, heavy mood is immediately suggested by a predominance of mid and dark tones.

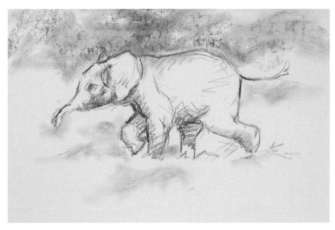

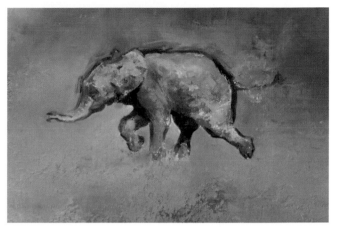

Underdrawing in charcoal Producing an underdrawing gives you a chance to become more familiar with your subject and to establish its principal lines and tones. Charcoal is capable of making fine lines of varying densities; it can also be smudged and blended to indicate subtleties of tone. It helps to squint a little at your drawing when assessing its tonal relationships.

Painting in tones The finished painting broadly follows the tonal guidelines set out in the charcoal drawing, though the dark outline of the elephant's body has been thickened to boost contrast against the background. Color works alongside tone in creating depth—the blue of the elephant's body complements the red/orange background.

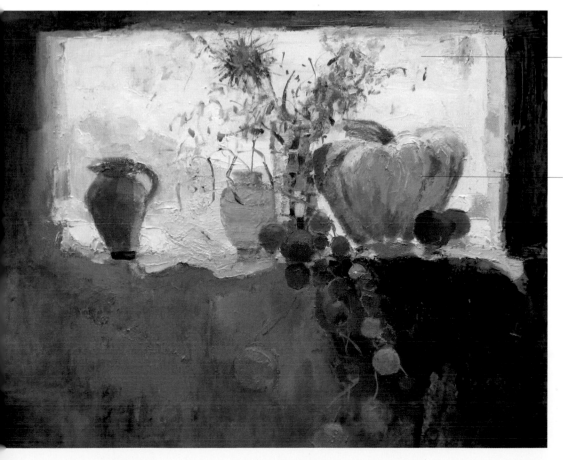

The lightest areas of the picture still carry many different colors. The light is almost blinding, but not totally—we are aware of vague shapes beyond the window.

The blue pumpkin forms a bridge between the lighter and darker sections of the picture.

Extremes of light and shade In this painting the artist has created areas of extreme contrast by framing the elements of the still life within a brightly lit window. Several strands of an orange flower burst from the window over the dark wall, inviting us into the picture and pulling us toward the light.

Gallery

The slow-drying, flexible nature of oils makes them the perfect medium for exploring and rediscovering the true nature of the objects around us.

Lemons ▲

The interesting contrast of warm and cool colors helps give real depth to this painting. The shape of the lemons is interestingly reflected in the dish. *Rachel Lockwood*

Daffodils ▶

The dark, cold blue of the walls and the stark white of the pitcher are broken by the overwhelming cheerfulness of these daffodils, just catching the sunlight. *Robin Bouttell*

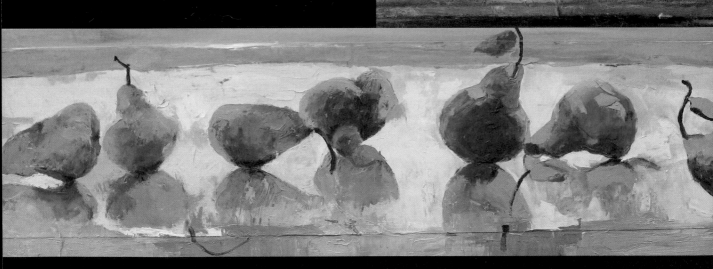

▲ Pears

These pears tumble across a windowsill like small animals at play; the composition feels entirely natural. It is held together by the blue band of sea, reflected in the pears' shadows. *Teresa Pemberton*

◄ Through the Poppies

The carefully selected colors and key shapes of the pink flower heads work to create clarity in this abstract painting, helping to make sense of the blue patterns of foliage below. *Matt Underwood*

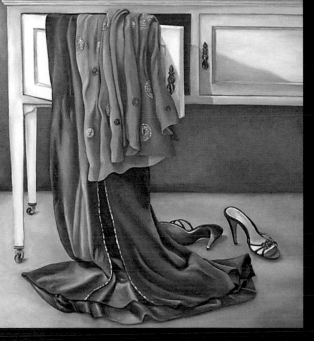

▲ The Book

Everyday objects are taken out of context and out of proportion in this colorful cubist artwork, challenging our perception of the world. *Juan Gris*

◄ Evening Out

The subtle lighting in this picture tells us that it is early morning, just as the randomly discarded clothes speak so eloquently about their owner's evening out. *Neil Smith*

1 Fish in a bowl

Traditionally, oils are painted on to stretched canvas or board, but there's no need to feel limited by the substrate. Oil works on a variety of grounds, as long as they are first sealed and primed so that the paints cannot soak into and rot the substrate. Here, a collaged newspaper background complements the subject— fresh mackerel in a bowl—perfectly, contributing to the atmosphere of the painting. The fish are contained within a deep vibrant red dish, which provides a great contrast against the blue and green hues reflected in the scales of the fish.

EQUIPMENT

- MDF board
- Red pencil, 2B pencil
- Craft glue; newspaper
- Brushes: varnish brush; No. 8 bright; No. 2, No. 4 filbert; No. 3 acrylics brush
- Turpentine or odorless thinner
- Liquin medium
- Cadmium red light, cadmium red middle, madder root tone, flesh tint, titanium white, jaune brilliant, Prussian blue, cobalt turquoise light, Naples yellow, translucent violet, cobalt blue, cadmium yellow deep, cobalt deep blue

TECHNIQUES

- Collage

PREPARING THE GROUND

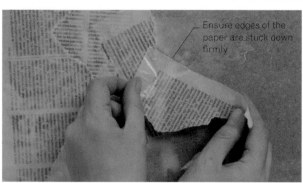

Ensure edges of the paper are stuck down firmly

Cover the surface of the board with craft glue. Soak torn strips of newspaper in the glue and compose them on the board.

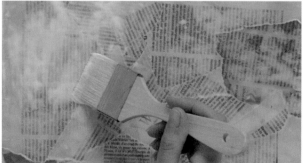

Allow the glue to soak in and dry. When the glue has set firmly, apply a second coat of thinned glue with a varnish brush to make an even, sealed painting surface.

1 Allow the newspaper collage to dry overnight. Trace the outline of the composition with the HB and red pencils. Begin painting the bold form of the red bowl with a mixture of cadmium red light, cadmium red middle, and madder root tone applied with the No. 8 bright. Make your brushstrokes follow the bowl's curvature.

BUILDING THE IMAGE

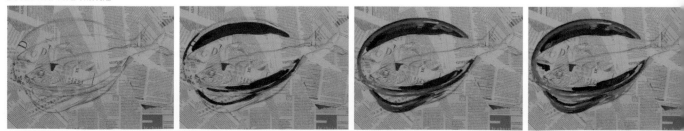

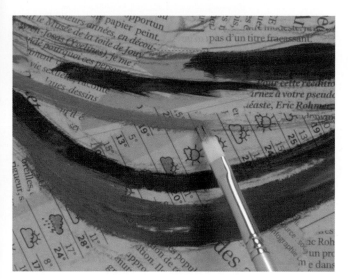

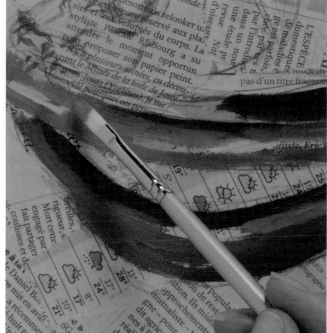

2 Add a little titanium white to the red color mixed in Step 1 and block in the handle of the bowl. Switch to a smaller brush—the No. 2 filbert—and work on the curved rim of the bowl, picking out the lighter contours of the glazed ceramic. Use the paint fairly thickly to ensure good coverage of the newsprint and work carefully along the sketched edges to define the shape of the bowl.

3 Mix cadmium red light with jaune brilliant. Use the No. 8 brush to paint the resulting orange hue on to the leading edge of the bowl to draw it forward in the painting. When working with wet paint on wet, it helps to lay down the darkest layers first, and work up in tone. Remember that light colors that include white are generally more opaque than those that lack white.

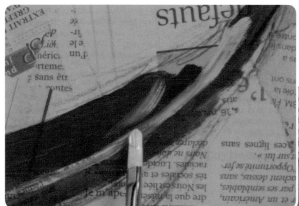

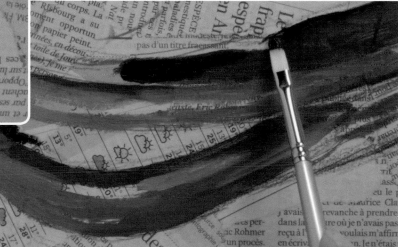

4 Mix together titanium white and flesh tint and add a bright reflection to the right of the red bowl, where light is reflected back on to its surface from the fish's tail. Add some Prussian blue to the original red mix and begin blocking in the shadowy areas of the inside of the bowl. Avoid black for shadow areas—it absorbs light.

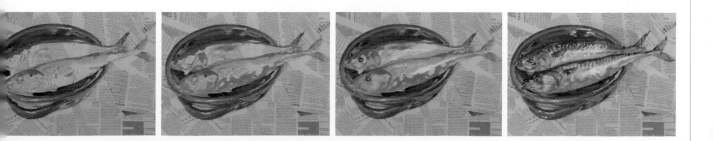

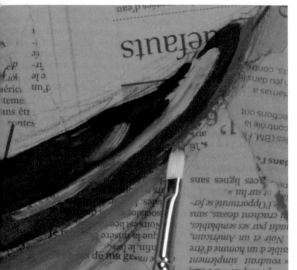

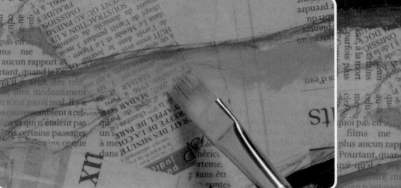

5 Color the outside of the bowl using the No. 2 filbert loaded with a mixture of translucent violet and flesh tint. Selectively add cobalt blue, cadmium red light, and jaune brilliant to emphasize small shifts of color in this area—feel free to exaggerate the colors.

6 Start developing the colorful sheen of the fish. Use cobalt turquoise light mixed with a little white; apply the paint, well thinned with turpentine, with the No. 8 brush. Add some Naples yellow into this mix and paint along the fish's head.

7 With a mixture of translucent violet and flesh tint, add the violet iridescence on the underside of the fish. Paint the peachy color of the light reflected on to the underside of the fish from the bowl—this is made up of Naples yellow, cadmium red middle, cadmium yellow deep, and a little titanium white. Use a clean brush lightly wetted with turpentine to blend together the blocks of color in this area.

8 Mix a green color from cobalt turquoise light, Naples yellow, and cobalt deep blue and work on the tails of the fish with the No. 2 filbert. Keep the paints only roughly blended—a little streakiness in the color adds spectral interest. Apply the green color very thinly on the fish tails, allowing the newsprint to show through the filamentous parts. Note how the striations made by the brush echo the structure of the fins.

BUILDING BLOCKS

Concentrate on the main areas of color, building blocks of different hue and tone that can be modified as the painting progresses. Don't be tempted to introduce detail too early because this will stifle the work. Allow yourself to be expressive, exaggerating color for creative effect.

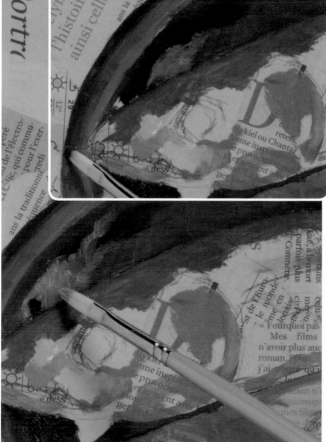

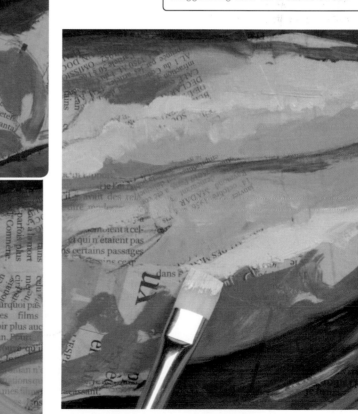

9 Make a mixture of translucent violet, flesh tint, and titanium white and apply in loose strokes to the inside of the bowl to indicate the reflections from its glazed surface. Apply cadmium red middle to define the rim of the bowl; darken this hue with a little cobalt deep blue and apply to the shadowed area within the bowl, at its curved base.

10 Start work on the bodies of the fish by laying down rough blocks of color to provide depth and contour: the blending and shaping can wait until later. Apply a mix of cobalt turquoise light, titanium white, and Naples yellow to the flank of the fish. Examine and exaggerate the colors reflected by the fish, adding cadmium yellow deep for the darker, yellower tones, and more titanium white for the highlights.

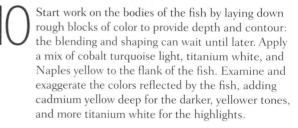

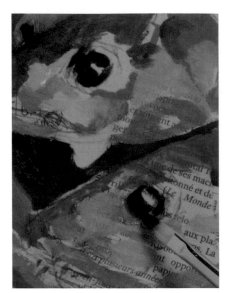

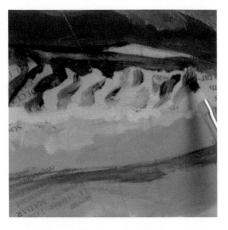

12 With the same color and the No. 4 filbert, mark in the dark, vertical stripes on the fish's bodies. Start with bold, heavy marks, freely working the stripes in harmony with the contours of the body. Wet the brush lightly with turpentine and gently blend the dark pattern with the layers of paint below; lowering the contrast by blending in this way gives the fish their sheen.

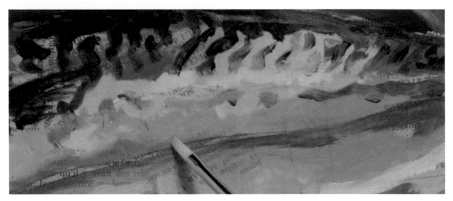

11 Mix cobalt blue, cobalt turquoise light, cadmium red middle, and Naples yellow, and apply to the eyes to give them depth. Use the fine No. 2 filbert for this precise brushwork. Paint along the body outlines, blending the darker blue paint with the green under-workings to provide relief.

13 Blend the areas of rough color along the body using a clean brush lightly wetted with turpentine. Run the brush in zigzag form between the two areas of color, dragging one color into the other, and vice versa. The larger the brush, the cruder the blending appears.

"The eyes hold the key to capturing an animal's soul."

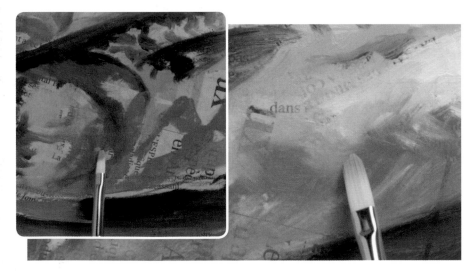

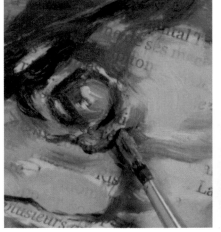

14 Continue blending color across the composition. Switch to progressively finer brushes to render the detail, finishing with the very narrow No. 3 acrylics brush. Leave some of the ground uncovered with paint, allowing the markings and texture of the newsprint to show through—this adds interest and context to the work.

15 With the No. 3 acrylics brush, introduce fine line detail to the head. Work over the dark eyes with a combination of the previously mixed paints to give curvature and reflection, which contribute to a realistic gaze.

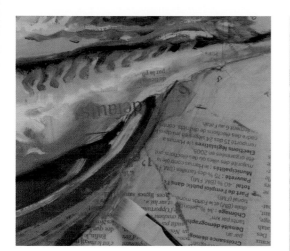

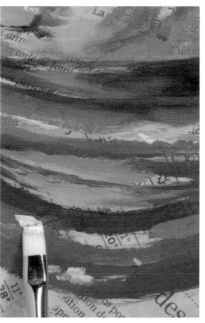

17 Boost the three-dimensional depth of the image by painting highlights on to the rim of the bowl using titanium white and the No. 8 brush.

16 Shade beneath the bowl using Prussian blue and cobalt turquoise light mixed with Liquin to thin the paint. Make the shadow dense immediately below the bowl and more translucent at a distance.

Fish in a bowl ▼

Reflections and exaggerated colors carry the form of the fish in this playful painting. The composition gains strength through the three distinct planes —the newspaper, bowl, and fish—each of which contributes distinct textures and colors.

②Flowers in a vase

Complete control over subject, composition, and lighting is one of the great attractions of still life painting, and flowers, with their astonishing forms and colors, are a perennial theme. The organic forms of the flowers in this painting are set against the architectural shapes—regular curves and lines—and smooth textures of the vase and the marble surface in the foreground. Each presents its own challenges in terms of color, from the bright hues of the flowers to the muted neutrals of the marble, which are among the most elusive tones to capture.

EQUIPMENT
• MDF board
• Red pencil
• Brushes: No. 8, No. 14 flat; No. 2 filbert; No. 2 bright
• No. 24, No. 26 palette knife
• Turpentine or odorless thinner
• Permanent alizarin crimson alkyd, cobalt turquoise light, cerulean blue, chrome green deep, Prussian blue, titanium white, purple lake, terre vert, cadmium orange hue, flesh tint, cadmium yellow deep, geranium lake, Davy's gray, Naples yellow, cadmium yellow pale, geranium red

TECHNIQUES
• Knife painting

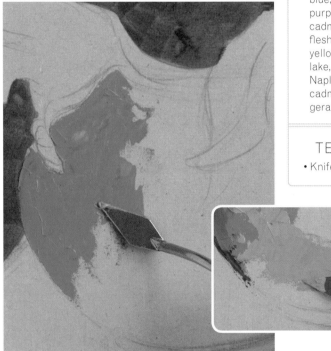

1 Loosely sketch the floral composition in red pencil and begin blocking in the background using the No. 8 flat brush loaded with the fast-drying permanent alizarin crimson alkyd; this can be worked over with minimum wait.

2 Begin the impasto work on the vase. Taking paint straight from the tube, mix cobalt turquoise light and cerulean blue with a little chrome green deep and apply with the small No. 24 palette knife. To this mix, add some Prussian blue for the shaded parts of the vase, and titanium white for the highlights and continue building up blocks of tone, working quite roughly at first.

BUILDING THE IMAGE

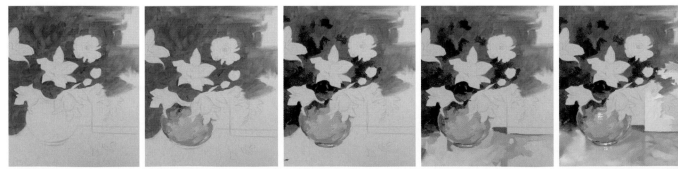

3 Establish the most obvious reflections and shadows in the vase, adding more titanium white and Prussian blue as necessary. Keep the paint thick and workable; you should be able to mix the colors directly on the MDF board.

4 Combine purple lake with a little cobalt turquoise light and apply to the shadows to the left of the vase. Add some marks with neat terre vert into the thick, wet paint to create a subtle impression of leafy texture in the shadows.

5 Build up the iridescent tones of the metallic lower lip of the vase, still using the No. 24 palette knife. Use a rough mixture of flesh tint, cadmium yellow deep, and geranium lake, toned down with a little Davy's gray to achieve more natural midtones.

6 Begin work on the marble floor. With the No. 8 flat brush, apply a mixture of cadmium yellow deep, flesh tint, terre vert, and cerulean blue where the foliage is reflected in the polished marble. Titanium white, flesh tint, cobalt turquoise light, geranium lake, and a speck of cadmium orange hue make up the basic, neutral color of the pearlescent marble.

7 Add some irregular streaks into the marble surface. These streaks are a subtly darker violet, made by mixing a little Prussian blue into the neutral color from Step 6. Using the No. 2 filbert, drag the paint lightly into loose, waving lines to represent the marbling; don't overwork the effect, or you'll risk spoiling the delicacy of the marble.

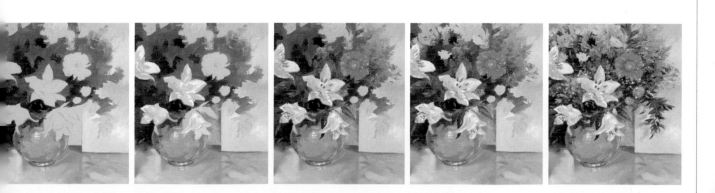

8 Blend together the tones in the marble with the clean No. 14 flat brush, lightly wetted with turpentine. Work cautiously; the areas of different color must remain just visible to give the marble its structure—overdoing the blending will result in a sheen of uniform color.

9 Ground the vase by adding shadow at its base with a mix of Payne's gray and the violet color from Step 7. Mix titanium white with a fleck of Naples yellow and add some reflected highlights around the bottom rim of the vase.

10 Mix cadmium yellow deep, flesh tint, terre vert, and cerulean blue with some Payne's gray and apply to the wall behind the flowers, using the larger No. 26 palette knife to cover the area. Judiciously add previously mixed colors to brighten or darken tones, adding interest.

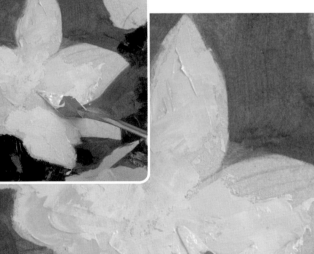

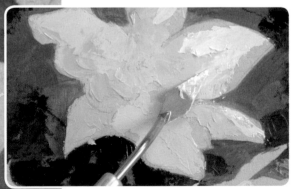

11 Lay down the base color of the lilies—flesh tint and titanium white—with the No. 24 palette knife. Apply a mixture of cadmium yellow pale and titanium white to the centers of the flowers; and with titanium white and a hint of flesh tint, highlight the outer petals.

12 Mix a vibrant green from cobalt turquoise light, cadmium yellow pale, and titanium white and paint the green parts of the lilies. Combine geranium red and flesh tint, and work this stronger pink color into the petals. Note the crossover textures achieved with the palette knife, where one raised area is laid over another.

13 Push the lilies forward in the composition by creating a strong color contrast with their glossy leaves. Mix Prussian blue and chrome green deep and thickly outline the lily leaves. Fill the leaf blades with a mixture of cadmium yellow pale and chrome green deep while the paint remains wet; blend the two green tones by dragging paint between the two with the No. 24 palette knife.

14 Mix cadmium orange hue with a little geranium red and paint in the bright stamens and pollen with the No. 2 bright. When the paint on the lilies has dried a little and become more plastic, use the palette knife to smooth, blend, and scrape the flower forms to refine their shapes

15 Build up the orange gerbera using cadmium orange hue straight from the tube. Follow the shape of the petals with the palette knife. Add a little geranium red to work on the darker center of the flower. Keep the orange paint clean—any contamination will kill the brightness of the color. Mix the orange with a little cadmium yellow pale, and apply this color to the highlights on the flowers.

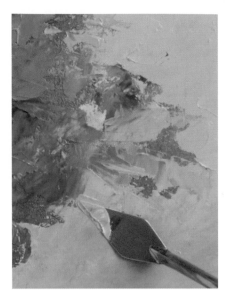

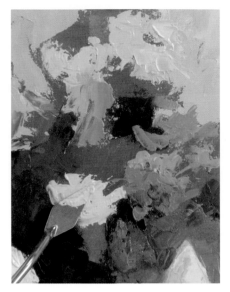

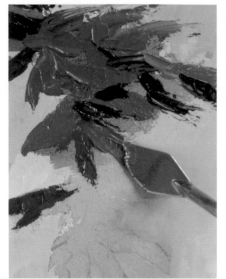

16 Add a little more green foliage, made up of chrome green deep and cadmium yellow pale, to the right of the gerbera. Add Naples yellow to this mix and continue the leafy forms to cover the remaining areas of red underpainting.

17 Loosely paint the forms of the yellow marigolds with the No. 24 palette knife and a mixture of cadmium yellow deep and titanium white. Roughly drag rays of adjacent greens and oranges into the yellow color.

18 Paint the tough, shiny broom leaves to the right of the composition using a thick mixture of terre vert and chrome green deep. Add Prussian blue and indicate the darker leaves that lie in shadow to create depth.

"Bold brushwork captures the joy of floral forms."

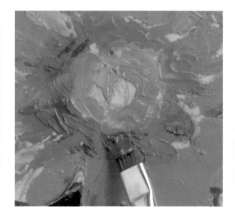

19 Mix titanium white with Naples yellow and run a palette knife along the surface of the foliage to suggest the shimmering highlights on the glossy leaves. Pick up the light green color from Step 18 with the No. 2 filbert. Dilute with turpentine and paint the diffuse shadows behind the leaves.

20 Create a sage green color by adding cobalt turquoise light to the light green mix from Step 18. Apply with a palette knife to the left of the arrangement for the gypsophylla foliage. For the flowers, mix in more cobalt turquoise light and white, and apply with the tip of the knife.

21 Use a mixture of geranium lake and cadmium orange hue, applied carefully with the No. 2 bright, to make a darker ring at the base of the petals of the gerbera; this "ruff" gives the flowers a more realistic shape.

Flowers in a vase ▶

The simplified, confident forms of the flowers are effective against the muted color of the foreground. The off-center position of the vase, the oblique overhead view, and stark lines of the walls contribute to the dynamism of the composition.

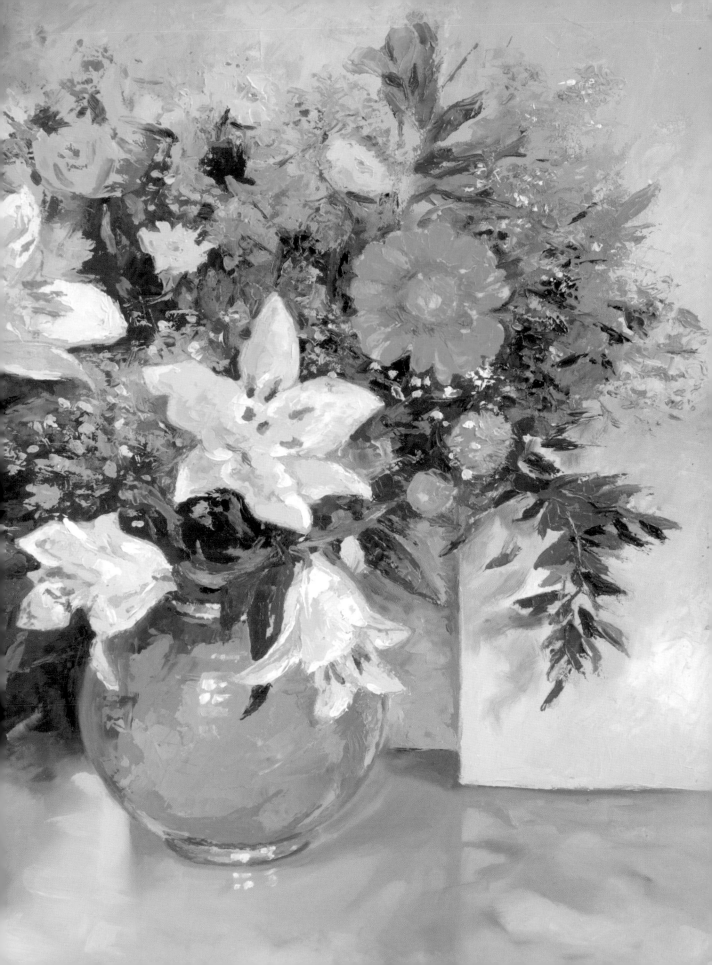

3 Spy glass

Ragging, impasto, and loose brushwork create a range of textures in this still life composition, which challenges with its diverse surfaces—from glass and metal, to stone and foliage. The composition invites exploration, the strong perspective and geometrical pattern of the spy glass leading the eye to the rough rectangular paving slabs and organic forms of the plants. The unusual viewpoint, where the subject lies flat on the ground while the background has vertical dimension, conjures the impression of an intimate scene, perhaps from childhood.

EQUIPMENT
- Canvas board
- 2B pencil
- P2, No. 24 palette knife
- Rag
- Brushes: No. 2 bright; No. 10, No. 6 filbert; No. 3 detail brush
- Turpentine or odorless thinner
- Naples yellow alkyd, cadmium red alkyd, Naples yellow deep, titanium white, natural Bohemian green earth, transparent gold ocher, cadmium red deep, Indian red, cadmium red middle, Prussian blue, lamp black, cobalt blue, cerulean blue, cadmium green pale, chrome orange tone, viridian

TECHNIQUES
- Ragging
- Impasto

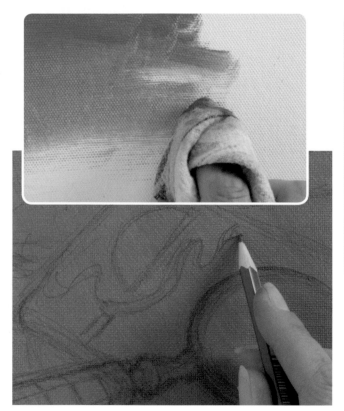

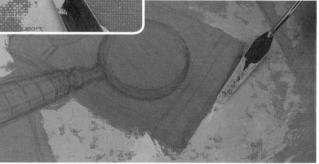

1 Create a colored ground as a base for the painting. Mix fast drying alkyd paints in Naples yellow and cadmium red with a little turpentine to make the paint run better. Roughly rag this warm red paint on to the canvas board. Allow the paint to dry, and then sketch the composition on to the ground using a 2B pencil; take care to get the perspective right.

2 Use a P2 palette knife to apply thick, smooth planes of paint over the pale flagstones. Use a rough mixture of Naples yellow deep and titanium white to create some variegation in the color. Continue the impasto work, adding some natural Bohemian green earth to the mix and applying this slightly duller color to the stone.

BUILDING THE IMAGE

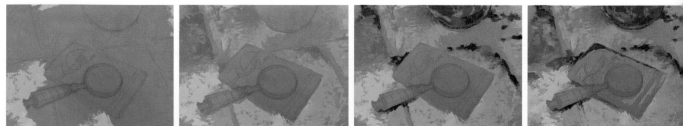

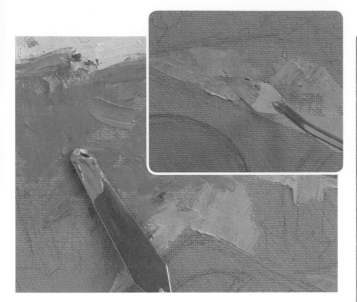

3 Mix Naples yellow deep, transparent gold ocher, and cadmium red deep into a deeper brownish color, and continue working on the paving with the P2 knife. Inject interesting textures into the impasto using the point and edges of the knife to scrape and scratch the paint. Switch to the smaller, more angular No. 24 palette knife to build a variety of marks in the more confined spaces.

4 Mix a darker brown from natural Bohemian green earth, Naples yellow deep, and Indian red and use the knife to add shadow to the flagstones toward the top of the composition. With the knife, blend this color into the lighter brown; mix some cadmium red middle into the paint, and add this tone to the flagstones.

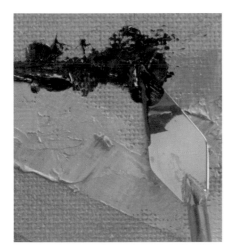

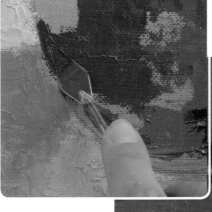
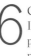

5 Add some Prussian blue into the mix from Step 4 and paint the dense shadow areas immediately behind the book and in the crevices between the paving slabs. Use the small No. 24 palette knife for this work.

6 Color the flowerpot at the top of the painting with a mix of Indian red and Naples yellow deep applied with the No. 24 palette knife; allow the colored ground to show through in places. Vary the tone by selective addition of more Indian red to the mix. Introduce Prussian blue for the darker shading that gives the flowerpot rounded form and relief.

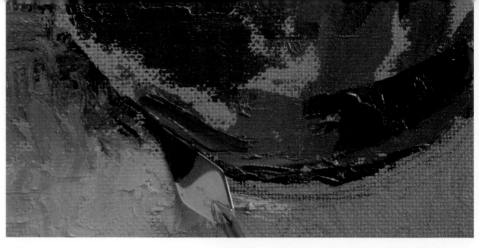

7 Add deep shadow under the handle of the magnifying glass with a blend of Prussian blue and Indian red. Use the tip of the knife to shape and mold the paint.

8 Blend the dark shadow areas in the paving cracks and under the flowerpot into the yellowish paint of the slabs themselves. In this way, build a series of textured greenish marks that suggest the moss and lichen fringing the edges of the paving slabs.

"A still life can carry strong narrative content."

9 Add mottled light to the left-hand side of the pot with a mixture of Indian red, titanium white, and Prussian blue. With lamp black and titanium white, add the gray mark along the crack between the slabs at the front of the composition.Introduce some flashes of gray to the surface of the slabs—these help create depth after blending.

10 Delineate the top edge of the book with a mixture of cobalt blue, cerulean blue, and natural Bohemian green earth. Use the palette knife to raise the edge, giving relief. Blend cobalt blue, cerulean blue, and a little white, and add this paler color to the central area of the book, lightening it with more cobalt blue as necessary.

11 Shape the spine of the book using parallel light and dark stripes of color. For the lighter stripe, mix natural Bohemian green deep and titanium white into the paler tint from Step 10. For the dark stripe on the lower part of the spine, mix Prussian blue and natural Bohemian green earth; blend the colors together roughly where they meet.

12 Mix cerulean blue, cobalt blue, and titanium white; apply this lighter blue to the book cover where it is visible through the lens of the magnifying glass. Omitting white from the mix, mark the curved, impressionistic reflection of a tree in the glass.

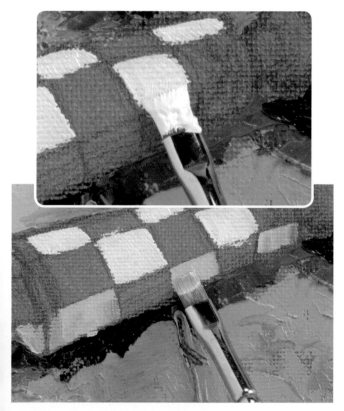

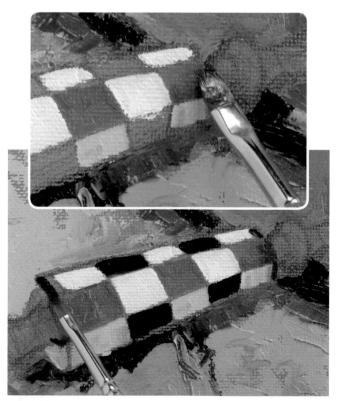

13 Paint the checkered handle of the magnifying glass with the No. 2 bright. Fill the squares on the upper side with titanium white modified with tiny specks of Naples yellow and lamp black to bring some life to the otherwise flat white. Add more lamp black to the mixture and carefully fill the light gray squares.

14 Mix more lamp black and a little cerulean blue into the gray paint and continue with the darker tones. For the black squares, and for the curved edges of the handle, use pure lamp black paint.

15 Use the gray from Step 14 to loosely outline the metal rim of the magnifying glass. Then add Naples yellow deep and cadmium green pale just within the inner rim, where the magnifying glass catches the reflections of the surrounding foliage.

16 Make a mixture of cadmium green pale, cobalt blue, and cerulean blue, keeping the colors partly unmixed and streaky. Roughly paint the foliage with the No. 10 filbert. Add more cadmium green pale and titanium white and continue adding paler leaves.

17 Block in any remaining areas of the book with cerulean blue, cobalt blue, and titanium white. Darken the shadows to the left by adding Indian red and Prussian blue. Use the No. 6 filbert. With the No. 2 bright, apply chrome orange tone over the decorative ribbon motif on the book cover.

18 Use the white shade mixed in Step 13 applied with the No. 3 detail brush to add highlights to the surface of the magnifying glass and its handle. With curved brushstrokes, blend the white color into the still-wet blue paint on the glass to emphasize its reflective qualities.

19 Mix lamp black with some warm tones picked up from the palette and outline the ribbon motif on the book using the fine No. 2 bright.

20 Combine viridian and cadmium green pale to add more detail into the foliage to the right of the picture. Twist the brush against the substrate to capture the patterns of light on the leaves. Strengthen the shadows beneath the book with lamp black, diluted with turpentine.

Spy glass ▼

A "found," rather than carefully arranged still life, makes a challenging subject because it is by nature more chaotic and spontaneous. Careful choice of viewpoint and framing help to control the composition, capturing a fleeting moment of personal significance.

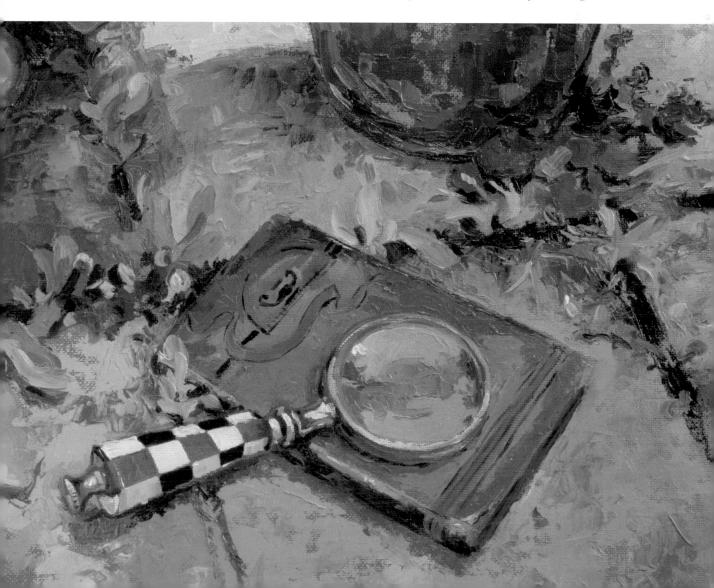

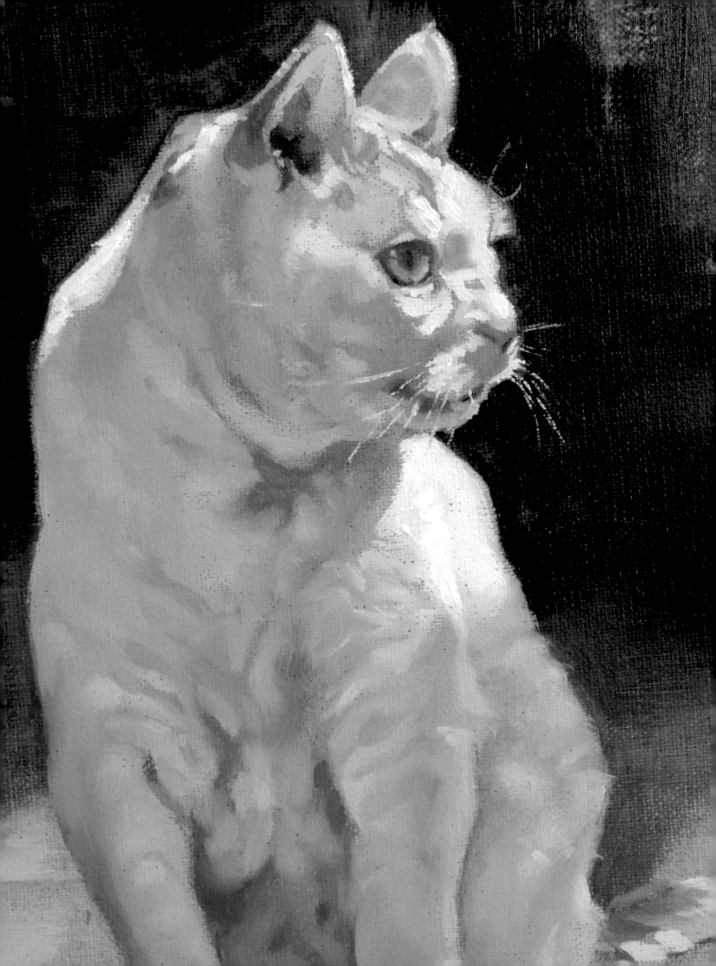

Life and Portrait

"A great portrait captures not only the flesh but also the soul of its subject."

Painting the face

Before painting a portrait, study your model closely under relaxed conditions—they are more likely to adopt characteristic expressions and poses, which will help you determine both an expressive pose and a possible composition for your painting. Lighting is especially important, as you will be describing the planes of the face through a well-defined series of tones. Check back to your model frequently, to make sure you are painting what is really there, rather than your idea of the figure before you.

MAPPING THE FACE

No two human faces are the same, but the human anatomy does impose certain basic proportions on facial structure. Following these proportions makes for more disciplined portraits that temper subjective observation and prevent a drift toward caricature. When painting a portrait, pose the model and establish the basic size and shape of the head—a flattened oval. This will guide the proportions of the body, which is 7–8 heads in height. Map out the basic facial features using the guidelines (*right*) constantly referring back to your model; the subtle differences between their face and the idealized face here will be vital in capturing a true likeness.

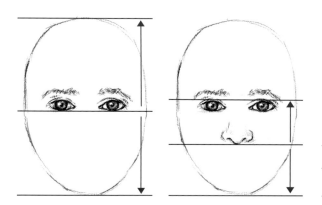

Position the eyes The bottom of the eyes sit on a line halfway down the length of the head. When learning to draw, people often place them too high, shortening the forehead. The distance from the eyes to the chin is equal to that from the eyes to the top of the head.

Eyes and nose You can establish the position of the nose by measuring the distance from the top of the eyes to the chin; the tip of the nose lies halfway down this measurement. The eyes:nose measurement is equidistant with the nose:chin distance.

Nose and mouth To find the position of the mouth, measure down from the tip of the nose to the chin. The bottom of the lips falls halfway down this point. The measurement from the base of the nose to the bottom of the lips is equal to that of the lips to the chin.

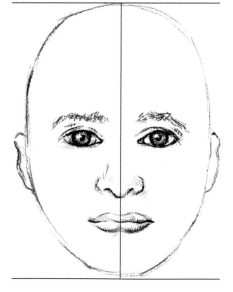

Basic head measurement To measure the head, hold your arm straight out in front of you, clasping a pencil in the fist, thumb upward. Hold the top of the pencil level with the top of the head, and slide your thumb down until it is in line with the chin.

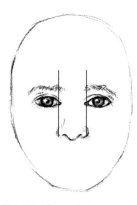

Nostrils Once you have established the vertical planes, pinpoint the horizontals. The major bone of the nose lies centrally on the face—you could draw a line down the nose to the center of the mouth. The outer edges of the nostrils line up approximately with the center corners of the eyes.

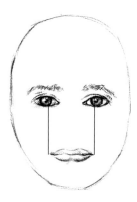

Mouth and eyes The eyes, which are all-important in a portrait, help to position both the nose and the mouth. The corners of the mouth line up with the center of the eyes, or just inside this point. However, remember that many faces are asymmetrical—look for the exact measurements.

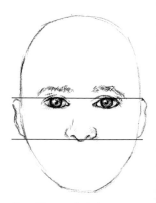

Ears The ears lie between the top of the eyes and the tip of the nose. In a perfectly proportioned person, the features may line up exactly, but check your model carefully to record the actual levels of the ears in relation to the eyes and the nose. Check and recheck as you draw the face.

THE FACE AND SKIN COLOR

With your sketch complete, begin by mixing the skin colors. Skin typically contains warm (advancing) and cool (receding) colors, almost always tinged with warm red or pink from the underlying blood capillaries. Block in broad areas of color and tone, then push the paint around the surface, allowing the features to build from tone, rather than line. Pay particular attention to the shape of the eyes and the mouth—they help to determine your sitter's mood and character.

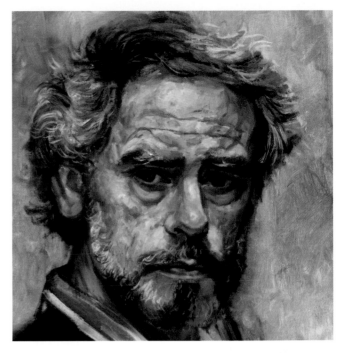

The darker tones immediately below the lower eyelid give roundness to the eye.

The colors and shape of the eyebrows add expression and balance the face.

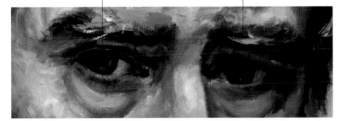

Capturing character The level of detail you can capture in a face-only portrait allows you to include every expressive fold around the eyes.

THE FACE IN CONTEXT

When painting a full-body portrait, you can use composition and background to help tell a story. If possible, identify and portray a characteristic pose; the particular way in which someone holds or arranges their body can tell us much about them. In this picture of *Val the Potter*, we guess that the sitter's hands are important before knowing the title of the painting; they frame his body and dominate the foreground.

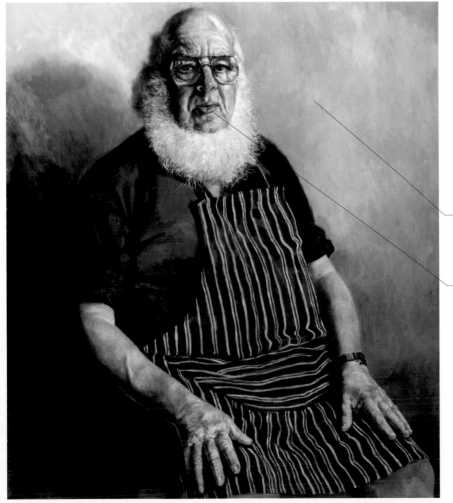

The earthy background colors reflect the same tones as clay— the potter's fundamental material.

The direct gaze holds our attention, while the open mouth adds movement to the face and makes us feel he is about to speak—this person really wants to communicate and engage with us.

Describing a life The pose, expression, and points of focus all add up to present a complete portrait of a person. In this painting the hands draw our eyes as much as the face, and they are a key part of the portrait. Finely detailed, they are highlighted against the dark apron and background. We sense that this is a "hands-on," practical person; someone who gets things done.

Movement and wildlife

Representing moving animals is a real challenge. Careful observation of the structure of your subject—the way its anatomy governs the dynamics of its movements—is needed before you can begin to make sketches that capture its essence. Painting is a delicate balance: a level of detail is needed to describe form, but too much information can weigh down the painting to the point of lifelessness.

CAPTURING MOVEMENT

We tend to carry pictures of animals in our heads that may bear little relation to the reality. Before painting any animal, study its movements by sketching small areas of its body over and over as it moves. Look for characteristic postures that typify the species. When sketching, do not allow the outline to become too definite; breaking up the line helps to imply movement. Use heavier lines on the parts of the body that face the direction of movement to show the animal's weight being pushed forward.

Sketching animals
Keep your sketches fluid but limit yourself to what you know to be anatomically correct. Measure when you can, rather than guessing proportions and remember that the position of the eyes is critical to producing a realistic result.

Painting movement Develop your gestural sketches into a working composition on the canvas. Refer constantly to your sketches and photographic reference to ensure that body proportions are correct. Try to paint the animal and the background together: block in some background at the same time as blocking in the animal. This will provide a link between the animal and its environment.

PAINTING ANIMALS FROM PHOTOGRAPHS

Photographic reference is invaluable for recording the contours, movement, and weight distribution of an animal. If possible, take pictures of your subject from a variety of angles—not just the eyeline you plan to use in your painting. These will help you assess the proportions and to identify asymmetries and imperfections that give your subject character. Good lighting—directional, but not too harsh— can do much of the work for you, providing the modeling that brings the subject to life.

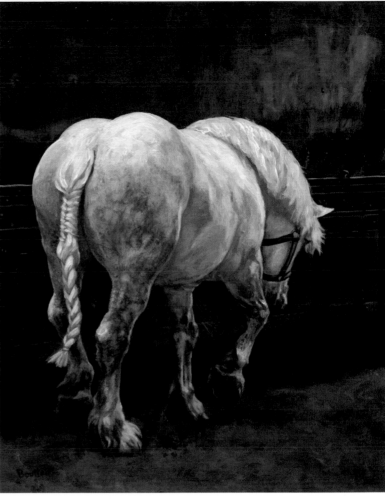

Horse portrait The unusual angle of this portrait serves to let us know that we are observing a private moment for this horse. The dark blue background allows the artist to tie in the animal and background, and add detail to the horse while still maintaining an awareness that its overall color is white.

FUR AND FACES

Painting realistic fur need not involve depicting each strand of hair. The effect of short fur can be achieved with short, tight strokes of the brush, combined with scumbling techniques, while long, flowing fur calls for long, soft brushmarks. Scraping back through layers of paint with a blending tool can create a good impression of bristly texture. Take the time to pick out details and highlights around the mouth, nose, and eyes—these are key to capturing personality.

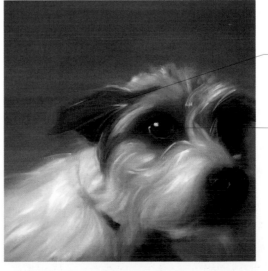

Long, layered marks made with a soft brush quickly build the texture of long fur.

The eyes express great character.

Dog portrait This is a busy dog—he looks purposefully beyond the picture. The composition, with the animal off center, suggests a snatched moment, while subtle blurring in the background implies motion.

Gallery

The vast range of colors, the luminous glazes, and the buttery texture of oils make them the perfect tools for rendering the surface of the skin.

Bürgermeister and the Louse ▶

The selection of older characters and the artist's clever use of palette helps to give this modern painting an antique feel. *Robin Bouttell*

▼ Marley

This painting has a strong element of design. Soft, natural details become simple patterns, but still work to portray the key elements. The stark contrast of the pillow against the red hair becomes a strong focal point, perfectly framing the sleeping face. *Penny Loudon*

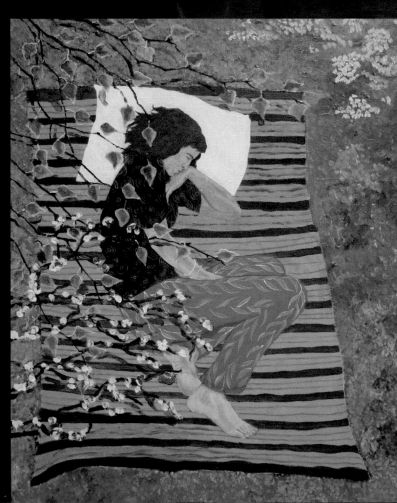

▲ Sleeping

Strong lighting and bold use of contrasting color in this painting help to emphasize the masculine angles and shapes of this figure. The limited palette of cool blues has been used to create a nighttime atmosphere. *Sam Robbins*

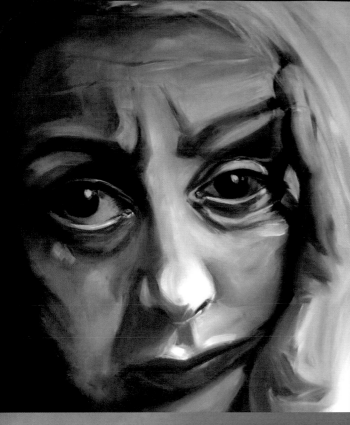

◄ Self Portrait

This study in character and mood makes good use of monotone colors to convey melancholy. The shadow on the left and the hand on the right add to a "hemmed in" feeling and force the viewer's attention into the picture—first on to the eyes and then the mouth. *Linda Roast*

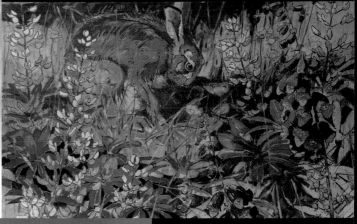

▲ Hare

This natural scene captures a casual private moment. Although the hare's eye in the center of the painting implies an awareness of our presence, the carefully placed foliage helps to provide a barrier between the creature and the viewer, allowing us to feel hidden and voyeuristic. *Andrew Haslen*

◄ Koi Pond

A fish is a difficult subject for an artist to portray with character, but here the fish swims up to—and even breaks—the surface, in its attempt to be friendly. The ripples draw us in closer to the painting's subject. *Rachel Lockwood*

4 Portrait of a woman

Posing the model looking up, toward the light source, rather than at the viewer produces instant drama in a portrait. At the same time, this approach sidesteps some of the problems presented by a face-on view, in which the shape of the face is defined by a complex interaction of shadows. This painting explores the challenge of reproducing skin—which is almost never uniform in color; it employs a limited palette of warm, advancing colors and cool, receding hues to produce depth in the skin tones and form in the face.

EQUIPMENT
- MDF board
- Craft glue
- Red pencil
- Rag
- Brushes: varnish brush; No. 6, No. 4 flat; No. 10 filbert; No. 2 bright; No. 0 long flat; No. 2 rigger
- Turpentine or odorless thinner
- Permanent geranium lake, Winsor violet, flesh tint, cerulean blue, titanium white, purple madder, Venetian red, chrome orange tone, jaune brilliant

TECHNIQUES
- Ragging
- Blending

1 Prepare the ground by priming the MDF board with craft glue thinned with water, applied with a varnish brush. Sketch the composition using a red pencil, carefully mapping the key features—the positions of the eyes, nose, and ears. Use light shading to establish the planes of the cheeks and the forehead.

2 Mix permanent geranium lake, Winsor violet, and flesh tint with a little turpentine. Pick up the thinned paint with a rag and apply briskly across the background. Avoid darkening the background too much; the face itself is in part shadow, so needs to stand out against the ground.

BUILDING THE IMAGE

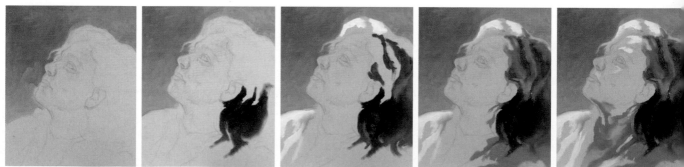

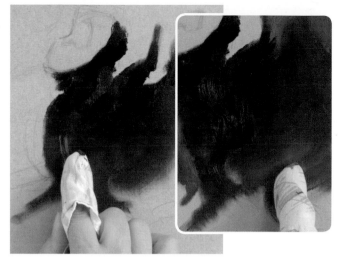

3 Continue ragging along the side of the face with cerulean blue thinned with a little turpentine. Using the No. 6 flat brush, work accurately around the face with a mix of cerulean blue, titanium white, and a little Winsor violet.

4 Mix purple madder with Winsor violet, and rag the darkest shadows behind the head. Use purple madder and Venetian red for the dark hair tones, and chrome orange tone and permanent geranium lake for the more orangey strands.

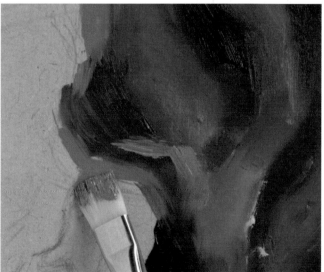

5 Mix jaune brilliant and flesh tint, and rag in the basic light tones in the hair; add a little chrome orange tone and continue. Rub some paint well into the board while leaving other areas raised, suggesting the unevenness of the hair.

6 Rag a mixture of permanent geranium lake, flesh tone, and Winsor violet to build the shadows on the model's left shoulder. Switch to the No. 6 brush to edge the hair next to the face precisely.

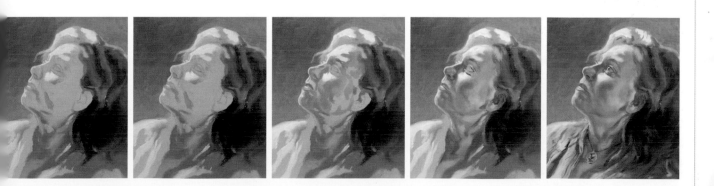

7 Mix a warm, bright color from geranium lake and chrome orange tone and rag this on to the model's neck. Add this paint to the color mixed in Step 6 and continue ragging. Be brave—the colors appear very bright, but be assured that they will give the face necessary warmth.

8 Apply a mixture of titanium white and cerulean blue with the No. 6 bright to make the shaped highlights on the face; use the same tones to highlight the shirt. Rag the broad areas of tone on the face, such as the cheeks and cheekbones, by adding purple madder to the mix.

9 Combine jaune brilliant and titanium white; paint the highlights along the forehead, the nose, and under the eye with the No. 6 filbert. With Winsor violet and flesh tint, continue blocking in the base skin colors on and around the forehead. Step back and examine your work periodically—beware of becoming too immersed in detail.

10 Add mid-tones to the face with a mix of Winsor violet, flesh tone, cerulean blue, and permanent geranium lake. Blend in some geranium lake, chrome orange tone, and light red, attenuated with flesh tone. Mix some flesh tint and jaune brilliant for the area above the cheekbone.

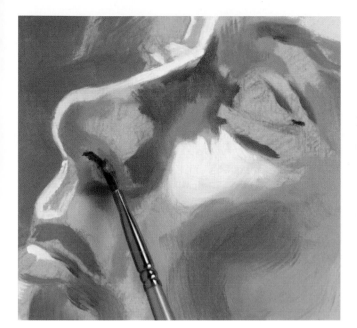

11 Paint the darker areas of the face with Venetian red and permanent geranium lake softened with flesh tint. Add the shadows beneath the eyes and nose with a mix of purple madder, Winsor violet, cerulean blue, and flesh tint. Use the No. 6 filbert throughout.

12 Blend the tones on the face with a No. 10 filbert brush, wetted with a little thinner. Smooth together the distinct blocks of color; at this point, the painting will become less stark and the complex mix of colors in the skin will begin to make sense.

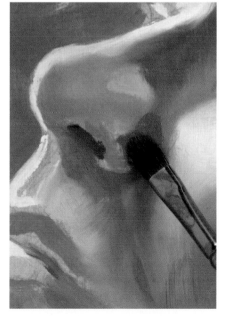

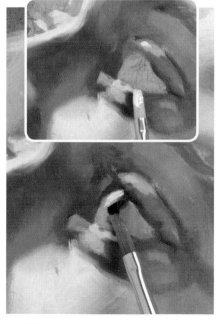

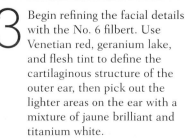

13 Begin refining the facial details with the No. 6 filbert. Use Venetian red, geranium lake, and flesh tint to define the cartilaginous structure of the outer ear, then pick out the lighter areas on the ear with a mixture of jaune brilliant and titanium white.

14 Throw the nose into relief by building the shadow at its base with a mixture of jaune brilliant, flesh tint, and chrome orange tone, cooled with cerulean blue. Switch to the No. 2 bright to bring out the lines around the eyes with Venetian red, flesh tint, and permanent geranium lake.

15 Add the highlight on the lower eyelid with titanium white and cerulean blue. With the No. 0 long flat, paint the iris with purple madder, cerulean blue, jaune brilliant, and Venetian red; darken this hue with more purple madder and add the dark pupil.

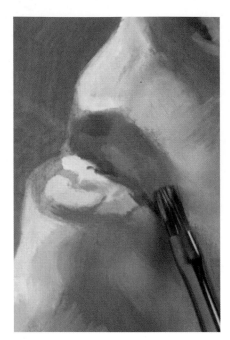

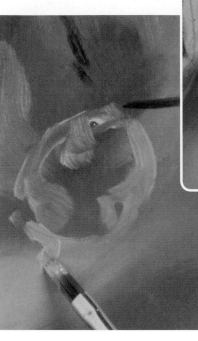

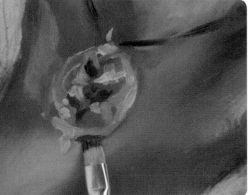

17 Form the pendant using quick brushstrokes of jaune brilliant, cerulean blue, and a little white; for the strap, use a loose line of the purple madder and cerulean blue. Add the shadow behind the pendant and strap—this is not linear, but follows the form of the body.

16 Select the No. 4 flat brush for the lips. Fill the area with flesh tint, permanent geranium lake, chrome orange tone, and Winsor violet. Add purple madder for the center line, and give them a moist appearance with highlights mixed from titanium white and flesh tint.

"Multiple layers of blended color give depth to skin tones."

18 Blend together tones in the shirt with a turpentine-wetted brush. Beware of removing too much paint at this stage and making the tones too light. Finally, introduce flowing lines to the shirt with gray-brown paint mixed from existing colors and applied with the No. 2 rigger.

Portrait of a woman ▶

Precisely controlled skin tone, with warm hues applied over a purple underpainting, is key here to building structure in the face. The clothing is kept deliberately vague to direct focus on to the model's expression.

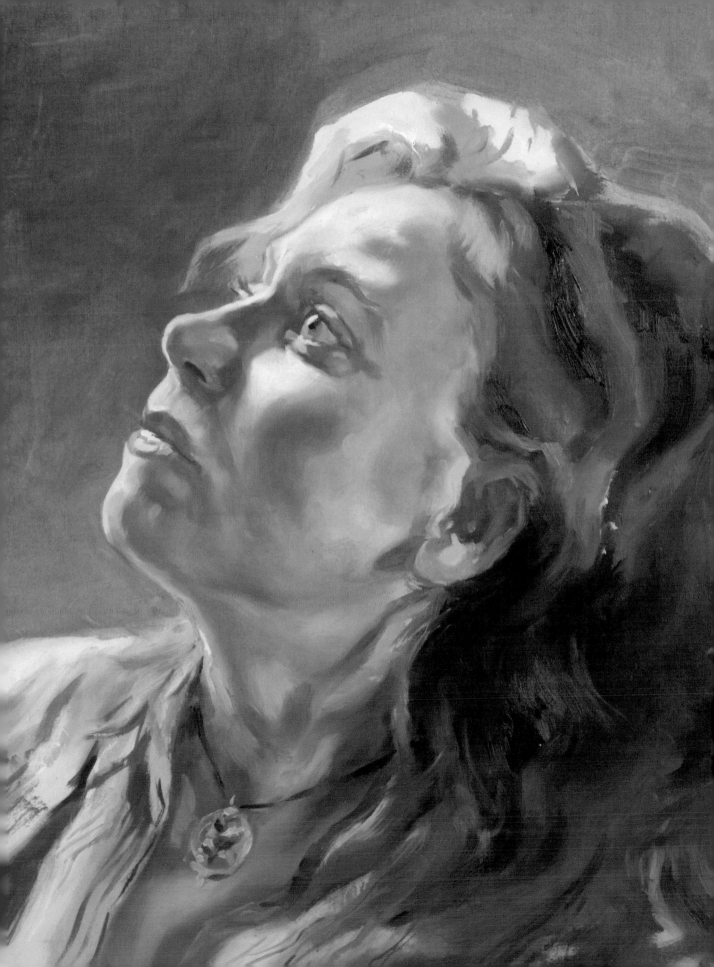

⑤ Seated figure

An unusual pose and minimal composition add intrigue to this study of the human body. Diffuse side illumination accentuates the gentle contours of the muscles, inviting careful analysis of shadow and anatomical form. The figure faces into, and is surrounded by, empty space that is loosely defined by ragging, giving the painting a calm, meditative quality. Portrait brushes—which are softer than normal oil brushes—are used for their gentler, more feathery marks, so aligning the painting's technique with its subject matter.

EQUIPMENT

- Stretched, primed canvas
- Red pencil
- Brushes: No. 4, No. 10 flat; No. 10, No. 6, No. 2 filbert
- Rag
- Turpentine or odorless thinner
- Cerulean blue, flesh tint, titanium white, Venetian red, jaune brilliant, Prussian blue, Davy's gray, permanent rose, translucent violet, transparent gold ocher, purple madder

TECHNIQUES

- Ragging

1 Sketch the figure using red pencil for visibility. Create the outline of the body and the contours of the main muscle groups. Add rough tones and shapes to establish the background.

2 Mix cerulean blue, flesh tint, and a little titanium white, and dilute this to a thin wash with turpentine. Apply the color using a rag wrapped around your fingers to establish the base tones of the background. Add some medium tones by mixing and applying Venetian red and flesh tint in the same way.

BUILDING THE IMAGE

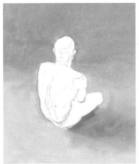
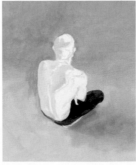
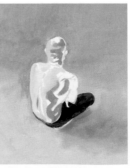

3 Add jaune brilliant to your color mix, making the paint slightly thicker, and rag in the shadow to the right of the body. Mix a new shade with cerulean blue, flesh tint, and titanium white, and rag the diffuse shadow ahead of the figure.

4 Build the left-hand edge of the body and head using titanium white, flesh tint, and jaune brilliant on the No. 10 filbert. Switch to the finer No. 6 filbert for the closer detail.

5 Mix a little more titanium white into the paint from Step 4 and pick out the curvature of the lower back. Vary the thickness of the paint to add interest, but keep all your work unblended at this stage.

6 Paint the pants to set out the darkest tones in the composition. Use Prussian blue mixed with permanent rose and a little Davy's gray and work the edges carefully using the No. 6 filbert. Mix some more Prussian blue into the paint to pick out the darker areas of fabric, adding subtlety. Pick out the top of the pants by adding white to the mix, using the No. 2 filbert.

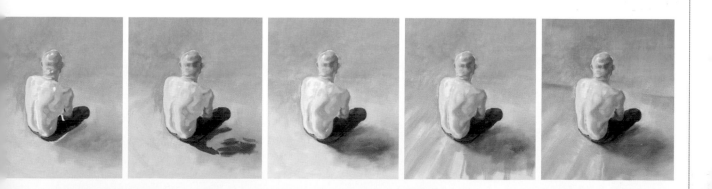

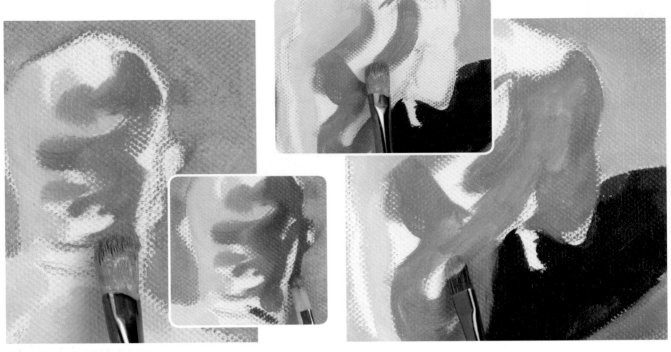

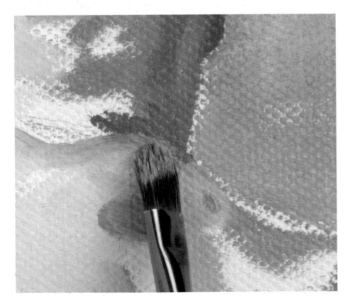

7 Add Venetian red into the purple color first mixed in Step 2, and paint the darker shadows between the folds of skin on the rear of the head. Blend with the existing paler tone on the head using the No. 6 filbert. Mix Venetian red, jaune brilliant, and flesh tint into the paint, and use the resulting darker, warmer red for the right side of the head, blending again to provide a rounded contour.

8 Mix translucent violet, flesh tint, and Venetian red and paint this cooler, more neutral shade on the right side of the back. Add transparent gold ocher and permanent rose to the mixture and apply to the ears, the right arm, and upper back, allowing the warmth of the paint to bring them forward.

"Use blocks of colors to pick out muscle groups."

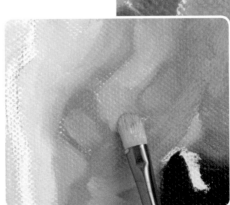

9 Mix some jaune brilliant, flesh tint, and titanium white and add some areas of light on the right shoulder blade. Use the same color to cover the unpainted areas of canvas on the left shoulder. Try to retain the delicate shape of the shoulder as you add the lighter tone.

10 Blend together the distinct blocks of colour on the back with the No. 10 filbert to create the curve of the body. Mix a basic color of translucent violet, flesh tint, and Venetian red; vary the proportions of each paint to build upon the base tone.

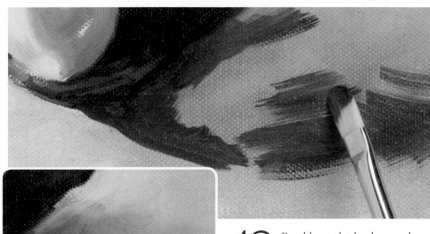

11 With translucent violet and Davy's gray build the dark tones in the folds of skin on the neck, on the skin just above the pant line, and in the shadow area to the left of the spine. The No. 2 filbert allows for greater precision. Don't be too concerned by the "lumpiness" evident in the skin—this will be addressed by further blending of the shadows.

12 Readdress the background. Mix Davy's gray and translucent violet and make some loose marks in the dense shadow to the right of the body. Then mix Venetian red, flesh tint, and jaune brilliant and roughly blend with the patches of the darker hue. Keep the work rough; the visible brushstrokes provide a painterly contrast to the smooth skin textures.

13 Mix some cerulean blue and titanium white and paint some cooler tones into the background area around the left shoulder, using the No. 10 filbert. The subtle, cool tones are recessive, and have the effect of pushing the left edge of the body farther forward in the composition.

14 Use the No. 10 filbert with a mix of flesh tint, Venetian red, and translucent violet to build the depth of the color on the right arm. Add more flesh tint to this mixture, and continue down the torso, picking up the light reflected back on to the body from the floor.

15 Add darker lines using a mix of transparent gold ocher, jaune brilliant, and permanent rose to pick out the contours on the back. Blend with a dry brush, removing the excess paint that would produce a hard line. This helps to tease out the subtleties of the soft muscle tissue.

16 Return to the upper area of the back and work over it with jaune brilliant and permanent rose, using the No. 10 brush to deepen the color and add texture. Work up, down, and sideways to add richness; keep the streaking visible. Add a little of the red color into the floorboards to balance the warmer tones in the upper area of the back.

17 Use the No. 4 flat brush and a range tones picked from the palette to add shadows between the ridges of the spine. Mix some cerulean blue with titanium white; paint a fine line on the underside of the leg, where light reflected upward from the floor hits the sitter's pants. This helps to lift the thigh, making sense of its angle.

18 Using the No. 10 flat brush, add broad brush marks in the lower left to suggest the floorboards. Build the marks in layers, first titanium white and translucent violet, then Davy's gray and white, then cerulean blue mixed with Davy's gray.

19 Return to the pants and reinforce the shadows on the fabric using a mix of Prussian blue and purple madder. When the body is dry, add subtle darkening in the small gap between the arm and the body.

Seated figure ▶

This picture is a lesson in understanding the subtlety of skin tones and finely observing muscle structure. The background acts as the perfect foil to the skin tones, across a full range of tones.

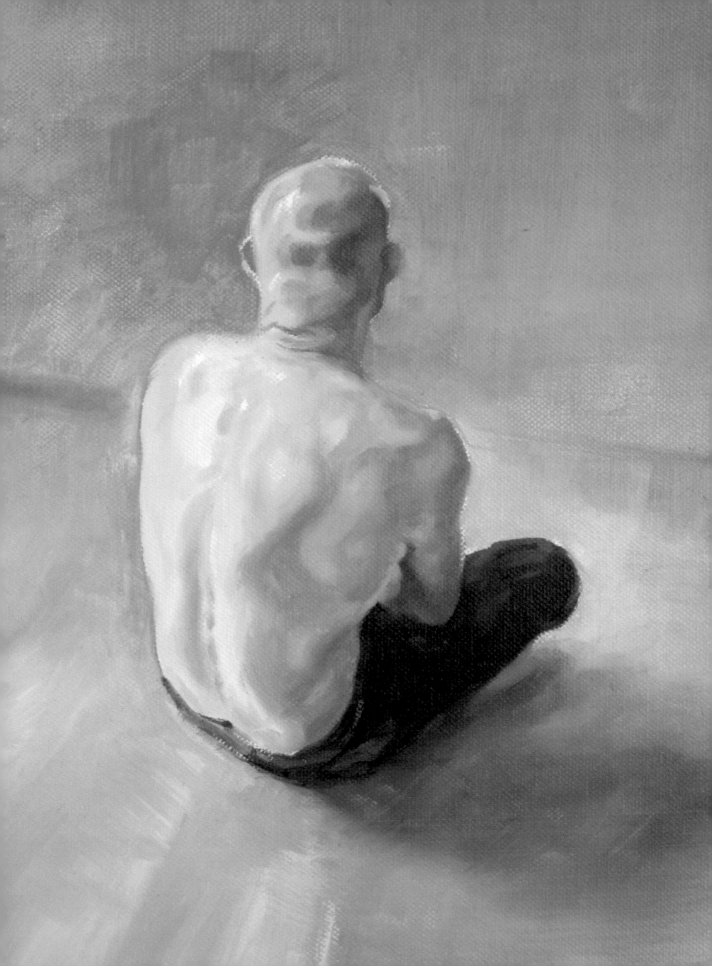

6 Cat portrait

Painting your cat is in many ways similar to painting a human portrait—you will need to choose a typical pose, and consider what features best express your sitter's personality. The posture of the body, tail, and ears are just as important as facial features in conveying character, and you'll need to work from photographs unless your cat is unusually docile. It helps to have some knowledge of feline anatomy, too; for example, the cat walks on its toes, which means that its ankle is located half way up its leg.

EQUIPMENT

- Stretched natural linen canvas
- Red pencil, 2B pencil
- Brushes: No. 12, No. 2, No. 4, No. 0 flat; S40 varnishing brush; No. 14, No. 8, No. 10 filbert; No. 6 bright; No. 3 detail; No. 6 portrait
- Turpentine or odorless thinner
- Prussian blue, Davy's gray, permanent rose, cerulean blue, Venetian red, cobalt turquoise light, titanium white, flesh tint, jaune brilliant, transparent gold ocher, translucent violet, purple madder

TECHNIQUES

- Blocking and blending

1 Sketch the cat in red pencil directly on to the linen canvas. Once you are happy with the pose, firm up the lines with a 2B pencil. Block in the background with Prussian blue applied with the No. 12 flat brush; vary the density of the paint to add texture, and work carefully around the outline of the cat.

2 Make short vertical strokes with the No. 12 brush loaded with permanent rose to suggest the shape of the red lounge chair in the distance. Continue blocking the background with Prussian blue, but leave the decking in the foreground untouched—its color is carried by the unpainted canvas.

BUILDING THE IMAGE

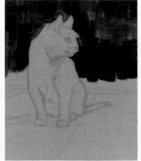
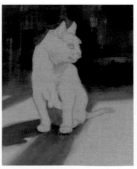
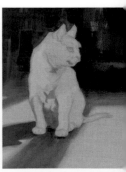

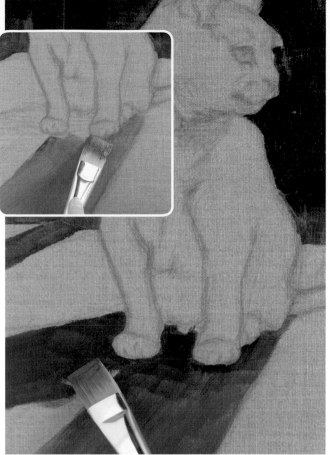

3 Mix a more vivid blue from cerulean blue and Davy's gray. Add flashes of this color to the background to hint at a distant light. Then combine Venetian red with Davy's gray and blend patches of this color into the still-wet Prussian blue of the background.

4 Use the S40 varnishing brush, dampened with turpentine, to blend the paint in the background and soften its color. Retain more prominent brushwork around the cat to draw it forward in the composition. The simple, uncluttered background makes a perfect foil for the detail of the cat.

5 Mix Davy's gray and Prussian blue and paint the shadow cast by the cat with the No. 12 brush. Use the same mix of paint to add the shadowed part of the decking, where it meets and blends into the wall.

6 Soften the edges of the cat's shadow by dry brushing the paint into the canvas with the No. 14 filbert. Dry brush the edge of the decking, where it meets the far wall, to suggest distance.

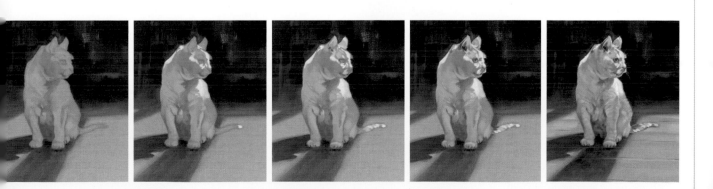

"Try to follow the direction of the fur when making marks."

7 Begin work on the shadowed areas of the cat's chest and chin. With the No. 8 filbert, apply a mixture of cerulean blue, Prussian blue, cobalt turquoise light, and titanium white, mellowed with Davy's gray. It seems odd to paint in blue, but animal fur is made up of many different shades.

8 Mix a brighter blue from cerulean blue, titanium white, and Davy's grey, and block in the left-hand side of the cat. With the paint still wet, mix Davy's gray and titanium white and work this into and over the blue beneath, to establish the broad contours of the animal's coat and underlying muscle.

9 Use a blend of the two mixes from Step 8 to paint the side of the cat's head. Add patches of this opaque blue-gray to other parts of the body; consistency in the base color ensures that different areas of the painting are visually linked to one another. While blocking in the head, pay close attention to bone structure; the cat's cheekbone sets the limit for the extent of the blue-gray paint in the shadows.

10 Mix Prussian blue with Davy's gray and shape the darker areas of the paws. Blend the color into the shadows beneath the paws to help "ground" the animal and make it appear to sit naturally on the decking.

11 Mix Davy's gray, flesh tint, and jaune brilliant for a color similar to that of the canvas. Overpaint marginal areas of blue to unite the cat's form with the unpainted background. Add a little more jaune brilliant to the mix and apply under the chin, where the fur catches reflected light.

12 Switch to the No. 2 flat for the bright fur on the cat's face, shoulder, and tail. Use a mix of titanium white and jaune brilliant for the face, then mix in varying quantities of the blues prepared in Steps 7 and 8 as you work down the shoulder.

13 Continue with the No. 10 filbert, adding the blue-white highlights to the face and down the left-hand side of the neck. Pay constant attention to the lie of the fur, especially on the head, where it changes in orientation many times.

14 Mix transparent gold ocher and jaune brilliant, warmed with a little permanent rose to establish the red hoop markings on the cat's tail. Use the same color to build the form of the cat's face, brows, and ears. Switch to the No. 2 flat for the smaller details. Make careful observations of the position of the animal's tail and ears—they play an important role in conveying the cat's mood and personality.

15 Refine the facial markings; add Venetian red and translucent violet into the reddish mix to build up the structure of the face. Keep working with blocks of color, resisting the temptation to blend colors together at this stage.

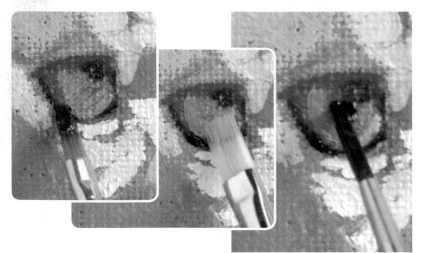

16 Use purple madder and Prussian blue for the inner rim of the eyelid, then fill the iris with a mixture of cobalt turquoise light and jaune brilliant. Use No. 2 and No. 4 flat brushes for this detailed work; switch to the No. 3 detail brush to define the small pupil in purple madder and Prussian blue.

17 Add titanium white to the first blue color mixed in Step 8 and revisit the lighter fur on the legs and body. With the No. 6 portrait brush, work over the still-wet paint beneath, blending and shaping the soft contours of the coat. Add some flesh tint and more blue, then similarly blend and contour the shadowed areas on the chest.

18 Deepen the fine line of the mouth, and the shadows in the ear canals, using a mixture of purple madder and Prussian blue applied with the No. 0 flat brush. Return to the chest and leg areas, using a dry No. 10 filbert to blend together the blocks of color.

19 Add an indication of texture to the decking in the foreground. With the No. 6 bright, make horizontal marks on the unpainted canvas using titanium white, jaune brilliant, and Davy's gray. Mix in cerulean blue and make fine lines for the cracks between the boards.

20 Select the No. 3 detail brush and load this with titanium white mixed with a fleck of jaune brilliant. Working very faintly, paint a broken line with the brush for the whiskers. A solid line would appear wrong because the eye can only detect broken highlights on fine strands.

Cat portrait ▶

A combination of spontaneity and discipline—especially in representing the rich colors and folded contours of the fur—helps to capture the character of this family pet. Dramatic lighting, a plain background, and controlled brushstrokes around the body give the cat emphatic presence.

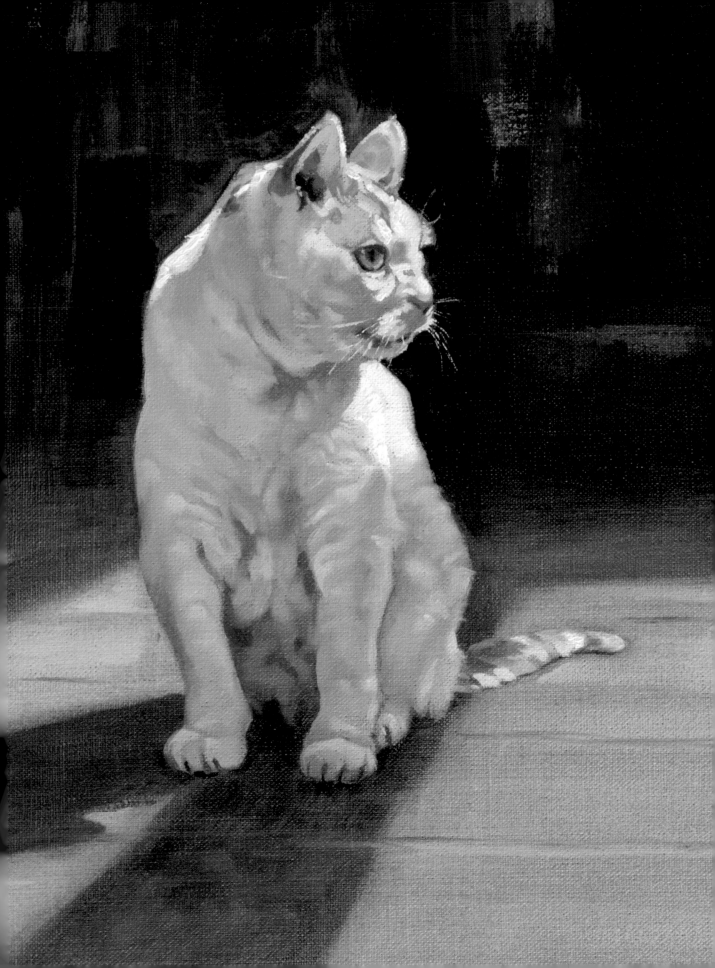

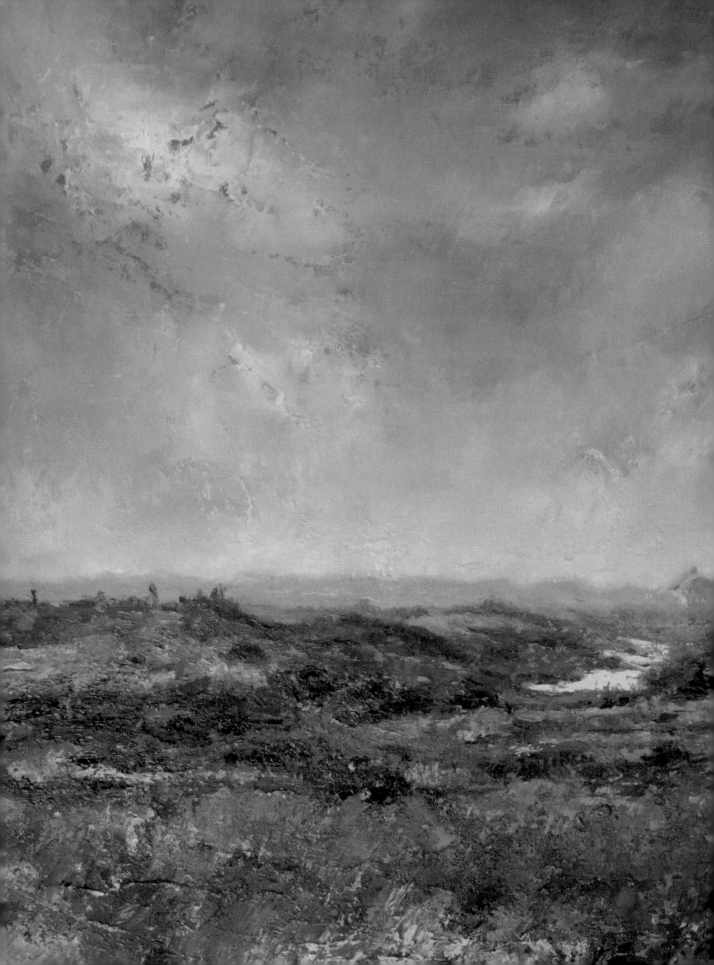

Landscape

"A landscape is not
only what you see, but
what you feel."

Realistic perspective

Perspective gives your paintings a sense of reality by positioning the viewer with respect to the subject and establishing the angle of view. This has an enormous effect on the character of the painting and our feelings toward the subject. An artist's chosen perspective can invite us to look down on or up to a subject; it puts us in the artist's place. Perspective can make us viewers, voyeurs, or participants.

ONE-POINT PERSPECTIVE

All pictures place the viewer at a certain distance from the subject, and so all objects within a painting are scaled relative to that position. In order to establish an angle of view, first draw in the horizon line, which is always at eye level. If you were viewing a street from above-rooftop level (*see below*), the horizon line—which is level with your eyeline—is above the rooftops. Any parallel lines below the horizon line need to be drawn in an upward direction, toward a central vanishing point. If you were standing at street level, the lines would run downward toward the horizon line, which would automatically lower with your eyeline.

The horizon line is always at eye level, which means that it moves to reflect the position of the viewer. Convergence lines meet at a point on the horizon called the "vanishing point".

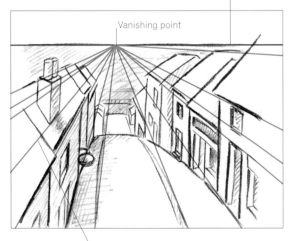

Vanishing point

Convergence lines (or *orthogonals*) are lines of objects that move away from the viewer to converge at the vanishing point.

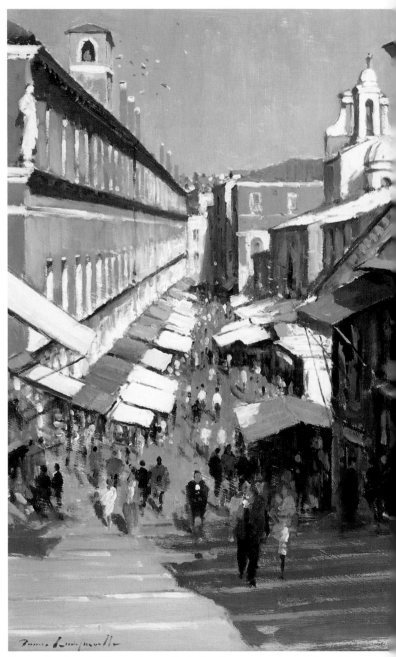

Converging lines In this street scene the horizon line—and our level of viewpoint—lies just above the center of the painting. The lines of the buildings give the picture perspective as they run toward a central vanishing point.

TWO-POINT PERSPECTIVE

In a two-point perspective, the parallel lines of an object disappear into vanishing points to either side. They sit on the horizon line, which moves up or down with eye level. In the diagram below, the horizon line falls midway up a building, as if we were standing at street level opposite the building. Parallel lines of objects lying above the horizon line move downward toward it, and any below the line rise up toward it. A two-point perspective can give your paintings a more dynamic but natural appearance.

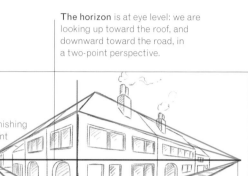

The horizon is at eye level: we are looking up toward the roof, and downward toward the road, in a two-point perspective.

Vanishing point

Vanishing point

The two vanishing points lie on the horizon to either side of the building. The farther apart you draw these points, the less dramatic the perspective, and the building grows smaller, receding.

Cityscape In this painting the artist has painted from an aerial view, with all the buildings falling below the horizon line. Convergence lines from the central building run toward two vanishing points.

LEADING THE EYE

Perspective provides information about the positions and dimensions of objects in a scene. However, it is not the only way to convey depth; color, texture, detail, and composition all play an important role in supporting formal perspective and in mapping out a "route" through the painting. For example, texture, detail, and purity of color all suggest proximity, while muted, hazy objects reinforce distance.

A wide, light stretch of water at the bottom of the picture welcomes the viewer, whose eye is captured by the flight of the owl, and led across the pools of water to the trees in the distance.

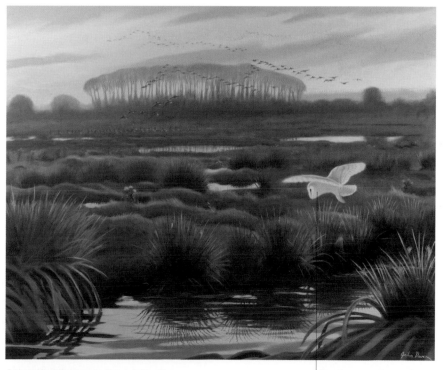

Attracting the eye In this painting the detail of the ripples in the water creates movement in the foreground of the landscape, and works to draw in the viewer's eye.

Ready comparisons of recognizable objects, such as the owl and the trees, gives us a sense of scale.

Atmospheric landscapes

Landscape painting involves creative thinking as much as it does close observation. You are expressing not just a view, but also your feelings about that view; you may want to change elements because they interrupt the mood you wish to invoke, as much as for reasons of composition. Spend time absorbing the landscape and noticing what becomes most important to you—this will provide the focus and mood for your painting.

COLOR AND LIGHT

Overcast winter days may be atmospheric, but their flat blue-gray light produces little contrast, making it difficult to express form in a landscape. Accents in warmer colors—or simply allowing traces of a colored ground to show through—can lift the mood and help provide depth (*below left*). On a sunny day (*below right*), colors become more vibrant, spanning a far greater range of tones. Intensity of color maintained even in distant objects summons up the clarity of the light.

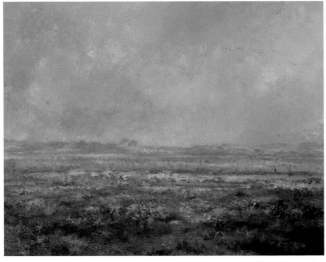

Flatter colors The low contrast of this painting gives it a melancholy mood; the muted colors of the foreground are progressively leached with distance.

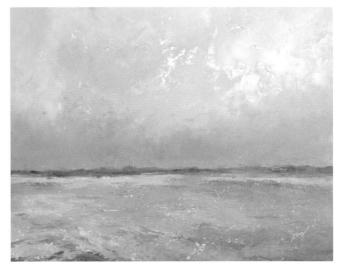

Brighter colors The recessive blue just above the horizon gives this picture depth, although colors remain intense throughout the composition.

CHOOSING TEXTURE

Texture is more than just a means of embellishing a painting—it plays an important role in setting the emotional pitch of a work. Impasto, for example, can capture the intensity of the artist's mood in its ridges and folds. Texture is also useful for expressing movement or stillness in the landscape itself: the sea in the textural seascape (*right*) seems positively alive, while the soft blending in the beach scene (*far right*) gives the image a languorous feel.

Textural landscape The heavy foreground texture of this painting adds to the perspective; notice how the texture diminishes as the sea recedes back toward the softer horizon.

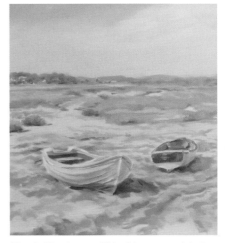

Blended landscape This picture was painted wet-on-wet, in thin layers, to soften the edges. The blending perfectly captures the warm, still haze of a bright summer day.

CHANGING THE SCENERY

You have enormous freedom when interpreting a landscape. Treat the scene in front of you as a guide for proportion and atmosphere, but you are at liberty to simplify the composition for impact, remove undesired elements, or provide a new focus to the work. Exaggerating existing features—such as rows or parallel lines within the landscape—is a useful way of building linear perspective in a flat landscape.

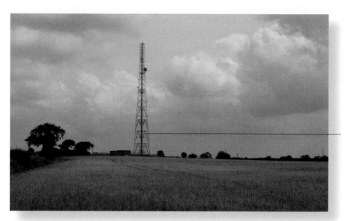

Blot on the landscape The pylon dominates this composition to the point that the other, natural elements are totally overwhelmed.

Removing the pylon frees the composition.

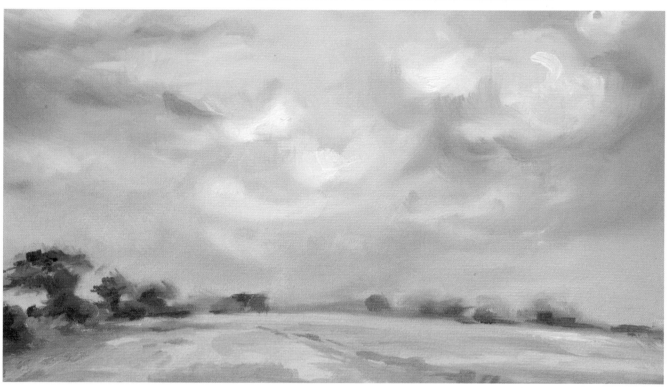

Edited image Removing the pylon transforms this composition into a pastoral scene. The new focus for the painting becomes the building on the horizon, which advances with its warm colors. The sky gains prominence—swirling brushwork gives depth to the cloud formations previously obscured by the pylon.

Abstraction for effect In this alternative approach to the scene, the pylon—or more specifically the lines and angles of its steel structure—becomes the focus of the painting. The flavor of the landscape behind comes through, but only through its atmospheric tones and textured brushmarks.

The lines of the pylon create movement, drawing the eye around the painting.

The angles of the pylon are echoed in the harsh brushstrokes of the landscape behind.

The great sweep of landscapes is dramatically captured in oils; their ability to render the luminosity of sky and water is unrivaled.

▲ East Bank

This picture carries the eye around the landscape very effectively. The eye is first drawn over the warm red light stretching across the land from left to right before being taken up into the sky, following the cloud outline in its path from light to dark.
Rachel Lockwood

▲ Waterloo Bridge

Strong one-point perspective draws us into this painting, toward the focal point of the bus. The sideways glance of the motorcycle rider, the bus, and the jutting angle of the crane on the right create a vigorous diagonal in the composition that complements the exaggerated bright colors. *Emily Cole*

◀ Harbor, North Norfolk

The dark edges of this painting create a window effect that guides the viewer's attention into the picture toward the focal point of the boats. The busy texture of the paint in the foreground of the picture emphasizes and creates a contrast with the feeling of calm around the boats. *Michael Chapman*

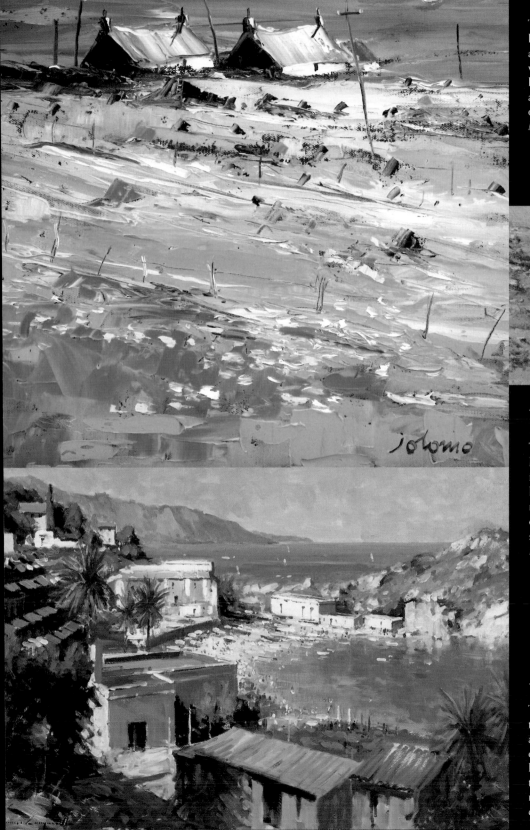

◀ Runrigs Balle An Triseic—Isle of Lewis

This landscape is a study of light and color. Unusually, the artist has painted a landscape without using green at all—the land is reflecting and absorbing all the brilliant hues of the sky. *John Lowrie Morrison*

▲ Spring Trees, Bearah Tor

The fragile nature of this landscape is perfectly depicted in the brittle rocks and broken lines of the trees. The blue rocks contrast with the land to create the effect of stepping stones into the landscape. *Dan Cole*

◀ The Beach, Taormina

The circular patterns of the two bays are accentuated by areas of shade. Exploration of each curve—upper and lower—finally brings attention to the area where the curves meet—at the beach in the center of the composition. *James Longueville*

7 Sea and sky

This painting of a simple, almost featureless, seascape allows an exploration of light—specifically the relationship between light in the sky and its reflection in the water. Limiting the palette and building the image in thick layers of impasto opens the door to highly expressive work, capable of showing movement of cloud and water and the almost tangible flickering of evening light and shadow. It is worth noting that this project is not cheap to execute—covering the large canvas in thick, textured paint is quite an investment.

EQUIPMENT
- Stretched canvas
- Red pencil
- Light molding paste
- No. 4, No. 24 palette knife
- Brush: No. 12 bright
- Turpentine or odorless thinner
- Cadmium red deep alkyd, flesh tint, titanium white, royal blue deep, Davy's gray, cobalt turquoise light, cobalt blue, Naples yellow, Prussian blue, translucent violet, jaune brilliant, natural Bohemian green earth

TECHNIQUES
- Molding
- Impasto

1 Draw the horizon line in red pencil. Apply light molding paste with the No. 4 palette knife, creating some flat and some ridged areas in tune with the contours of the waves and clouds.

2 Allow the paste to dry, then use the No. 12 bright to paint the canvas with a thin glaze of cadmium red deep alkyd. Mix flesh tint with titanium white, and apply with the No. 4 palette knife over the cloud to the left. Work the paint in a variety of directions.

BUILDING THE IMAGE

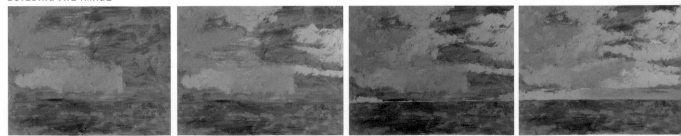

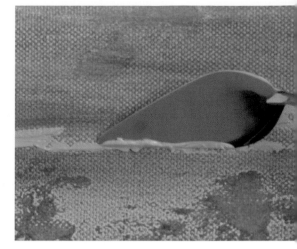

3 Mix royal blue deep, titanium white, and Davy's gray, and begin laying down blocks of blue color at the top of the picture. Note how the red combines with the color, making a green-gray.

4 Add a little cobalt turquoise light to the blue mix and work along the skyline, just above the horizon. Use the edge of the palette knife, and keep the horizon straight. Vary the pressure on the knife to create a more interesting, textured line.

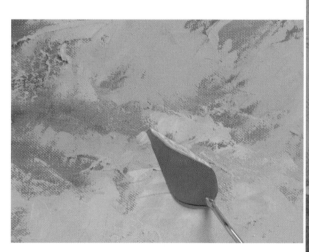

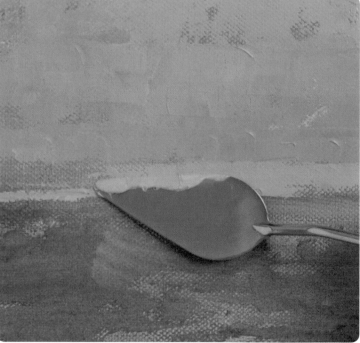

5 Mix titanium white with royal blue deep and work into the sky with the knife, blending into the paint beneath. Add first Davy's gray, then cobalt turquoise light to the mix and paint two bands above the horizon line. Roughly blend the colors together, dragging paint from one band into another.

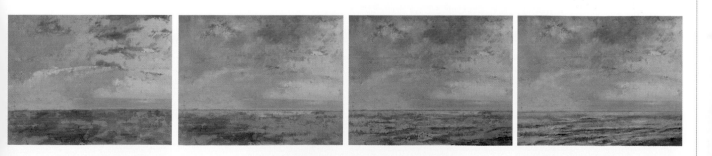

6 Mix Naples yellow, titanium white, and a fleck of cobalt blue and apply to the sunlit areas of the large cloud that hovers above the horizon. Blend this muted yellow color into the bands above the horizon with a fingertip. Maintain the strong line of the blue bands on the horizon.

7 Add titanium white and more cobalt blue to the paint from Step 6. Use the knife to add this greenish hue to the right side of the large cloud. Make short strokes with the knife, dragging in lines of the surrounding color to add dynamic texture.

8 Introduce dark colors at the top of the painting. Use the knife to lay down blocks of roughly mixed Prussian blue, royal blue deep, and cobalt turquoise light at the top. Add a little titanium white as you descend. Scrape the paint round in a spiral to capture the energy of the dark distant clouds.

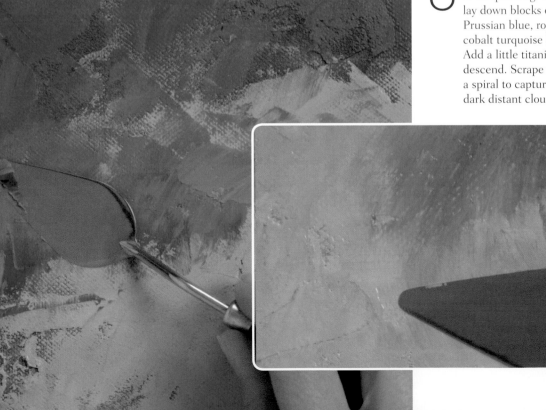

9 Add translucent violet to the blue from Step 8 and thin the paint with a little turpentine. Apply with the palette knife, dragging the paint across the peaks of the molding paste. Leave patches of the red base color visible—their presence across the canvas helps unite sky and sea.

10 Use the blue from Step 8 mixed with some Davy's gray to underscore the horizon line; this defines the transition between land and sea. Load the knife with flesh tint, titanium white, and Naples yellow, and drag this down the blue paint into the sea area.

"Build paint in shallow layers—thick applications of impasto may crack."

11 Mix cobalt blue, Prussian blue, and royal blue deep with some Davy's gray to knock back the color. Begin building the tones of the sea to the right-hand side. Add flesh tint and Naples yellow to this mix, and apply this paler paint to the left-hand side of the sea area.

12 Roughly mix cobalt and Prussian blues; apply to the bottom right in horizontal planes to suggest shadows of the oncoming waves. Mix jaune brilliant, titanium white, cobalt blue, and flesh tint; use the edge of the No. 24 palette knife to sculpt the shapes of the wavefronts.

UNITED SKIES

The sky is far more than the backdrop to a painting—it can assume as much, or more, importance than the foreground. The sky should integrate well with the rest of the image—using similar brushstrokes and leaving exposed areas of underpainting across the canvas help to unite all the elements in the composition.

13 Mix Prussian blue, cobalt turquoise light, and natural Bohemian green earth. Use the No. 24 palette knife to make narrow marks on the sea, giving depth to the waves. Add highlights to the wave crests with titanium white, modified with cobalt blue and Naples yellow. Add the shadows and highlights sparingly—too many will upset the color balance between sea and sky.

14 Run the knife along the horizon to blend together the blue bands and smooth the surface of the paint. Lack of texture at the distant horizon makes the area recessive, and so more distant.

15 Work over the whole sea area with the No. 24 knife, blending and smoothing certain areas, while leaving others textured. Varying the detail in the painted surface adds depth.

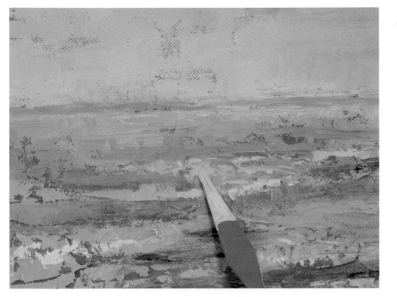

16 Step back and carefully reassess the balance of the piece. Add some pure jaune brilliant highlights to the clouds to the left, and corresponding sparkles—in titanium white and Naples yellow—where they are reflected in the sea.

Sea and sky ▼

The sea is not an even surface. In some places it is a mirror, in others it absorbs the light; it interacts with illumination from the sky in myriad ways. This painting draws light from the sky into the sea, and explores how colors and tones are modified by the water. Commonality of color helps balance the painting, as does the composition, with the large elongated cloud above the horizon offsetting the busy texture of the waves.

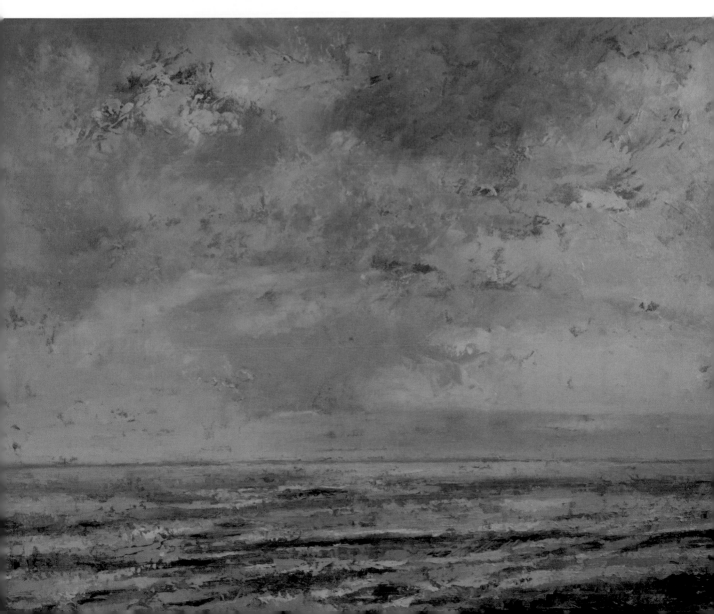

8 Desert hut

Vibrant colors and a ground textured with pumice gel help to convey the rugged simplicity of this desert landscape. The arrangement of foreground hues into a patchwork of distinct colors gives the scene a primal honesty, and working without a pencil underdrawing helps retain a sense of rawness. A key feature of the work is the red underpainting which is allowed to show through strongly, uniting the disparate areas of color in the foreground and sky and providing a warm tone that permeates the scene.

EQUIPMENT
- Canvas board
- Coarse pumice gel
- No. 4, No. 24 palette knife
- No. 12, No. 8, No. 6 bright; No. 4, No. 10 filbert; No. 14 portrait brush; No. 2 flat
- Turpentine or odorless thinner
- Jaune brilliant, cadmium red middle, flesh tint, titanium white, Naples yellow, cerulean blue, permanent mauve, Davy's gray, Prussian blue, Venetian red, cadmium green pale, raw sienna

TECHNIQUES
- Modeling in pumice gel
- Impasto

1 Smear coarse pumice gel on the foreground areas occupied by clumps of vegetation using the No. 4 palette knife. Create perspective with the gel—make the paste smoother and thinner with distance. Leave to set overnight, then, with the No. 12 bright, paint over the whole board with a mix of jaune brilliant and cadmium red middle, thinned with turpentine.

2 Begin blocking in the base tones of the sky. For the warm areas of sky near the horizon to the left of the picture, use a mixture of flesh tint and titanium white applied with the No. 8 bright. Add Naples yellow and continue to the right. The pale area close to the horizon is recessive and creates immediate depth in the composition.

BUILDING THE IMAGE

3 Mix cerulean blue with titanium white and use the No. 8 bright to block in the upper part of the sky. Add some more cerulean blue to the mix and apply this darker hue at the top of the canvas to boost the appearance of depth.

"Emphasize cloud forms that echo features on the ground."

5 Mix titanium white with a little flesh tint and loosely swirl the paint into the upper sky with the No. 4 filbert, forming clouds that appear to radiate from the middle of the sky. Use the dry No. 14 portrait brush to blend the clouds into the background and draw out their soft, wispy shapes.

4 Drag strokes of permanent mauve and cerulean blue from the top of the sky toward the middle of the painting, so enhancing perspective. Blend the sky areas with the dry No. 12 bright, uniting the tones.

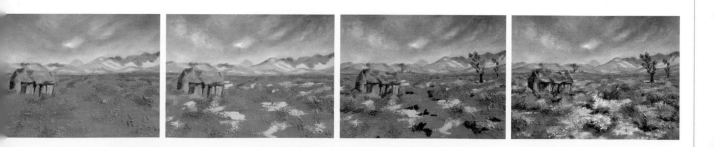

6 Outline the distant mountain range with the No. 8 filbert loaded with a mix of permanent mauve, Davy's gray, and cerulean blue; note how this picks up some of the paler color beneath. Add a little Prussian blue to darken the mix, and continue sketching the mountains, keeping your strokes loose to push them back into the distance.

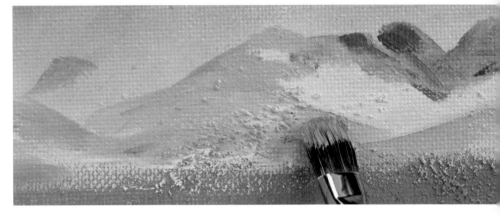

7 Paint the slopes of the mountains in a range of earth colors, softened to suggest the hazy distance of the slopes. Begin with a warm yellow made up from Venetian red and jaune brilliant. Apply this to the sunlit slopes with the No. 8 filbert.

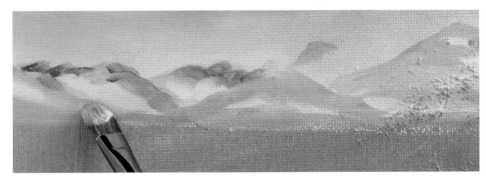

8 Continue building the forms of the mountains. Add some Prussian blue to the mix from Step 7 to make a gray-green earth hue for the lower, darker slopes of the mountains. Mix a new color from jaune brilliant, flesh tint, and titanium white and use this to add to the mountain forms.

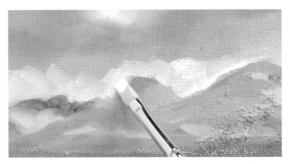

9 Load the No. 2 flat brush with pure titanium white. Carefully work around the outlines of the distant mountains to introduce bright cloud above the horizon. The light color of this cloud appears to push the mountains forward in the composition.

10 Blend the white cloud back into the wet paint of the sky using the dry No. 10 filbert. Slightly soften the outlines of the mountains against the sky. Allow the paint over the mountain areas to dry for at least one hour before applying any more marks in the foreground.

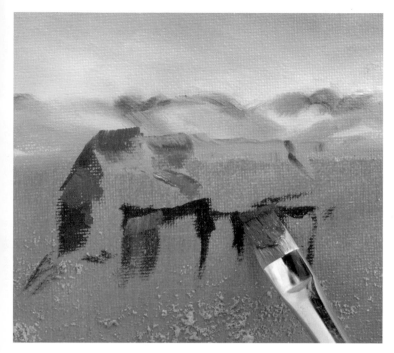

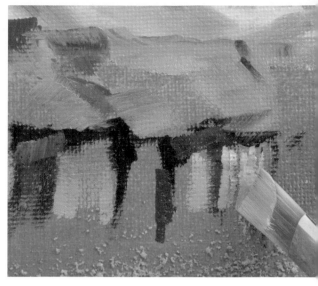

11 Sketch out the structure of the hut in the foreground using the No. 2 flat. Begin with a dark mix of Venetian red and Prussian blue in the shadow areas under the eaves, then develop the rusty structure with raw sienna mixed with a little Venetian red.

12 Mix cerulean blue, Prussian blue, and titanium white and continue coloring the hut with the bright hues reflected from the sky. Feel free to boost the saturation and intensity of the colors, which will be blended together later.

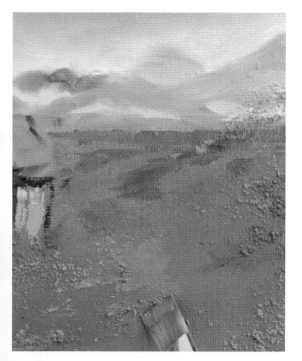

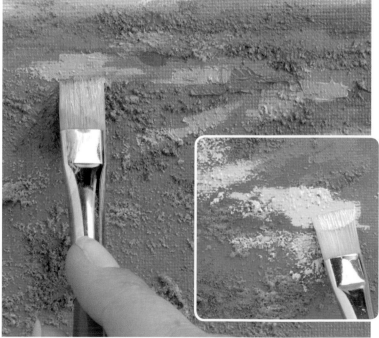

13 Mix a muted green color from Davy's gray, Venetian red, and cadmium green pale and loosely paint clumps of vegetation. Work the paint into the crevices in the pumice in some areas; in others, pass the brush over the top so that traces of red show through.

14 Add clumps of vegetation in a variety of plant tones. Begin with an intense green from cerulean blue, jaune brilliant, and Davy's gray; then cadmium green pale and jaune brilliant; then Naples yellow. Try to form receding paths of vegetation that draw the eye into the painting; imply detail in the foreground by following the shapes established by the pumice to create more definite bushlike forms.

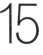 **15** Return to the sky to add some texture and life to its surface. Mix titanium white with a little cerulean blue and apply with the No. 24 palette knife. Push and scrape the paint on to the surface thinly but energetically; this energy will transfer visibly to the painting.

16 Mix Venetian red, titanium white, and raw sienna; apply this tone with the No. 2 bright, contributing form to the hut. Darken the paint with Prussian blue. Add density to the shadows of the hut and map out the shadows of the most prominent bushes, which are key points in this sparse desert landscape.

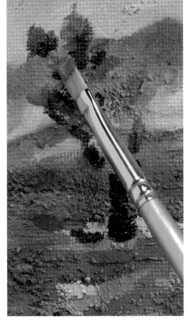

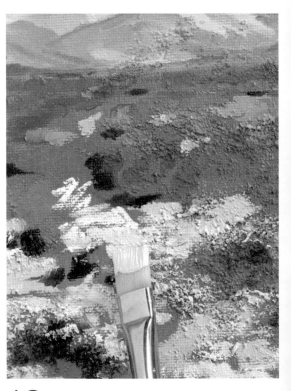

17 Use the dark hue from Step 16 with the No. 2 brush to paint the trunks of the trees to the right-hand side of the composition. Use the flat tip of the brush to indicate the lateral branches, keeping your marks loose for energy.

18 Mix cadmium green pale and cerulean blue for the foliage of the trees. Feather this lighter green into the still-wet darker paint beneath to achieve variation in the shade of the foliage. Don't try to "paint" the leaves—use loose suggestion only.

19 Paint the pale patches in the foreground that correspond to areas of foliage and flowers. First use pure titanium white, then add Naples yellow. Work over the pumice with the No. 6 bright, borrowing the texture of the substrate. Repeat using a mix of cerulean blue, titanium white, and cadmium green pale.

21 Apply titanium white straight from the tube with the No. 24 palette knife to create textures in the central foliage. Add traces of other colors from the palette to the white, and introduce textured areas across the painting.

20 Mix permanent mauve with Prussian blue and titanium white. Lightly stroke over the pumice-textured surface to depict clusters of purple flowers.

Desert hut ▾

Pumice gel and textural knife painting provide tangible surfaces for the foreground vegetation, while the distant mountains are finished in smoother, blended tones. The end result is convincing depth and atmosphere in a loose, impressionistic painting.

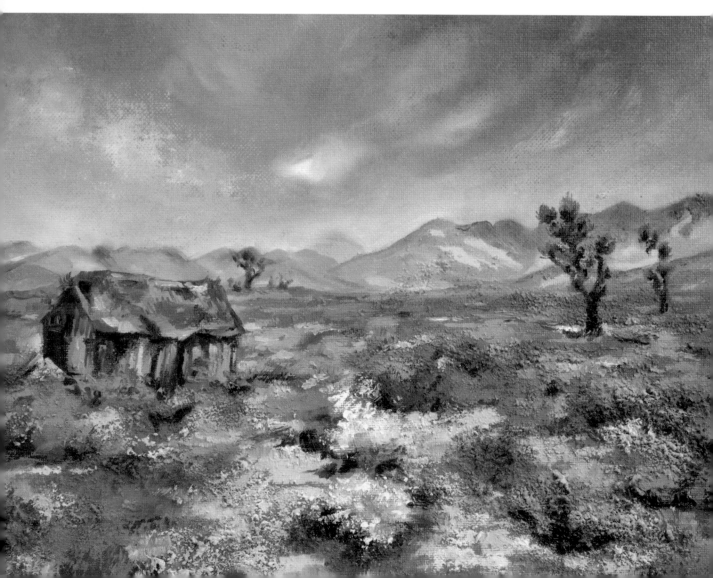

9 Cityscape

Bold streaks and blocks of simplified color create both structure and movement in this busy city scene. The tangible sense of energy comes from deliberate contrasts between adjacent colors, an absence of blending, and the use of black in foreground details, which further boosts the impact of the bright colors. There is no preliminary underdrawing, which makes for a free-flowing and lively painting; this impression is reinforced by the vignetted underpainting, which summons up the vivid immediacy of an extended sketch.



EQUIPMENT

- Stretched canvas
- Brushes: large varnish brush or decorator's brush; No. 12, No. 8, No. 2 bright; No. 6 flat; No. 3 detail brush
- Turpentine or odorless thinner
- Flesh tint alkyd, cobalt blue deep, sky blue, cobalt turquoise light, madder lake brilliant, titanium white, yellow ocher light, cadmium yellow pale, permanent mauve, Mars black, Prussian blue

TECHNIQUES

- Broken color



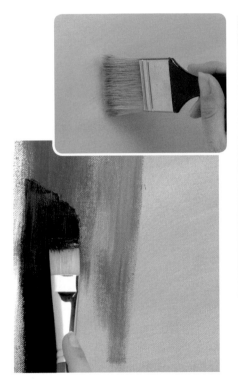

1 Thin flesh tint alkyd with turpentine and work loosely over the canvas with the varnish brush. Mix cobalt blue deep, sky blue, and cobalt turquoise light; build the left dark edge of the image with the No. 12 bright; add madder lake brilliant for the darkest form.

2 Begin filling the sky between the skyscrapers with a mixture of cobalt turquoise light, titanium white, and sky blue. Blend the colors only roughly, and work them strongly on the canvas with the No. 12 bright so that the brushmarks are visible.

3 Add more cobalt turquoise light to the mix and block in the building to the mid-left—essentially a wall of sky reflected in glass. Use the same color to add the reflection of the terrace in the glass of the dark building to the left.

BUILDING THE IMAGE

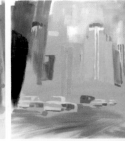

4 Establish the stone building that frames the painting to the right. Mix yellow ocher light with madder lake brilliant and apply with the No. 8 bright. Switch to the No. 6 flat to paint a mixture of cobalt blue deep, cobalt turquoise light, and titanium white on to the vertical strips of windows on the building to the rear. Add more titanium white and cobalt turquoise light; loosely mark in the windows of the brown building.

5 Mix cadmium yellow pale and titanium white and use the No. 6 flat to paint simplified, gestural marks that set out the shapes of the rushing yellow cabs on the street. Apply madder lake brilliant for the outline of the red minibus, and use this color to paint the background of the advertisement to the left.

6 Block in the central building using the No. 8 bright with yellow ocher light, titanium white, madder lake brilliant, and cadmium yellow pale. Use the No. 2 flat to apply titanium white to the central tier of windows. Add permanent mauve to the yellow mix and paint shadows into the staggered top of the building.

7 Mix madder lake brilliant, cadmium yellow pale, and permanent mauve, and continue work on the central building, adding layers of shadowed structure to the rear. Use the same color to build density on the shadowed sides of the yellow cabs. Keep the work blocky and graphic.

8 Set out the base color of the road in sky blue, cobalt turquoise light, and permanent mauve using loose strokes of the No. 6 flat. Sweep the brush from left to right, retaining prominent marks that suggest the direction of travel and enhance perspective.

9 Make an oily blue color by mixing cobalt turquoise light, cobalt blue deep, and titanium white. Use the No. 6 flat to add the reflections in the windows of the cabs. Deliberately keep some gaps between adjacent blocks of color and refrain from blending tones together—this discontinuity helps to boost the feeling of movement in the painting.

10 Mix madder lake brilliant and cobalt blue deep and block in the face of the building on the left of the street, just behind the red advertisement. Use this dark tone to add shadow density beneath the cabs, and detail elsewhere in the painting.

11 Add more cobalt blue deep to the mix from Step 10; use this darker color for the deeper shadows—for example, the dark parts of windows of the cabs and cars. Use the No. 2 bright for this finer detail.

13 Mix a bright green color from cobalt turquoise light and cadmium yellow pale, and establish the forms of the trees. Keep the shapes blocky rather than organic, and the colors exaggerated, to chime in with the geometric artificiality of the urban setting.

12 Combine madder lake brilliant with yellow ocher light and paint the far edge of the dark foreground building with the No. 6 flat. The warm color captures the reflection of the brown stone building on the opposite side of the street; this symmetry of color helps to unite the composition.

14 Mix sky blue, cobalt turquoise light, permanent mauve, and titanium white, and paint the building behind the trees. Blend this color very lightly into the green of the trees.

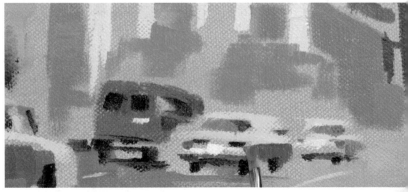

15 Reinforce the face of the building that carries the advertisement with madder lake brilliant. Add some titanium white details with the No. 2 bright, and then use the same brush and paint to add in the road markings.

16 Continue building the forms of the cabs—add their red tail lights with madder lake brilliant and cadmium yellow pale using the No. 2 bright. Mix a dark, almost black, hue from Prussian blue and madder lake brilliant and apply this with the No. 3 detail brush to pull out the outlines of the vehicles.

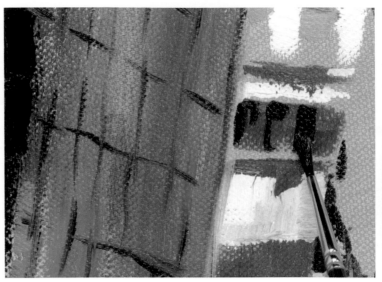

17 Contribute to the sense of perspective by picking out selective detail in the foreground. Use the No. 3 detail brush to add door handles to the cabs; darken the paint by mixing in Mars black, and block in the tires of the vehicles.

18 Use the No. 3 detail brush to delineate the window frames of the dark building to the left in a mixture of madder lake brilliant and Prussian blue. Add the silhouettes of the street lights and the shadowy details on the red advertisement.

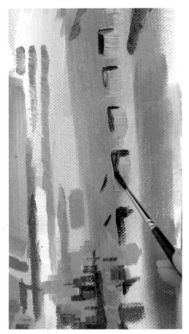

19 Return to the windows of the brown stone building. Use the No. 3 detail brush to make a right angle at the top of each to indicate the recession of the window in its frame. Make faint parallel marks on the front face of the building.

20 Paint the windows of the central building in a mixture of cobalt turquoise light and cadmium yellow pale. Vary the hue of certain windows by adding madder lake brilliant to give the impression of reflection.

21 Add the traffic lights that arch over the road, painting their forms in cobalt turquoise light, cadmium yellow pale, and Prussian blue. The arches provide a frame within the painting, adding to the strong perspective created by the brushstrokes on the road and the movement of traffic.

Cityscape ▼

This painting captures just enough detail to describe the scene, then allows the blocky, vibrant color to summon up the jittery city atmosphere. The graphic approach is very suitable for portraying a modern city; it allows for fast, spontaneous work that reflects the movement and energy in the composition.

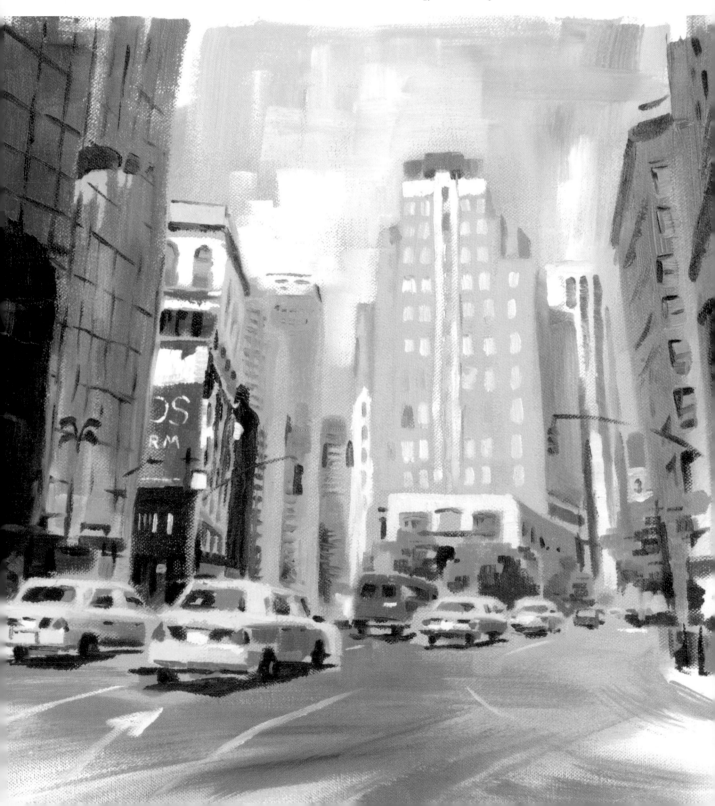

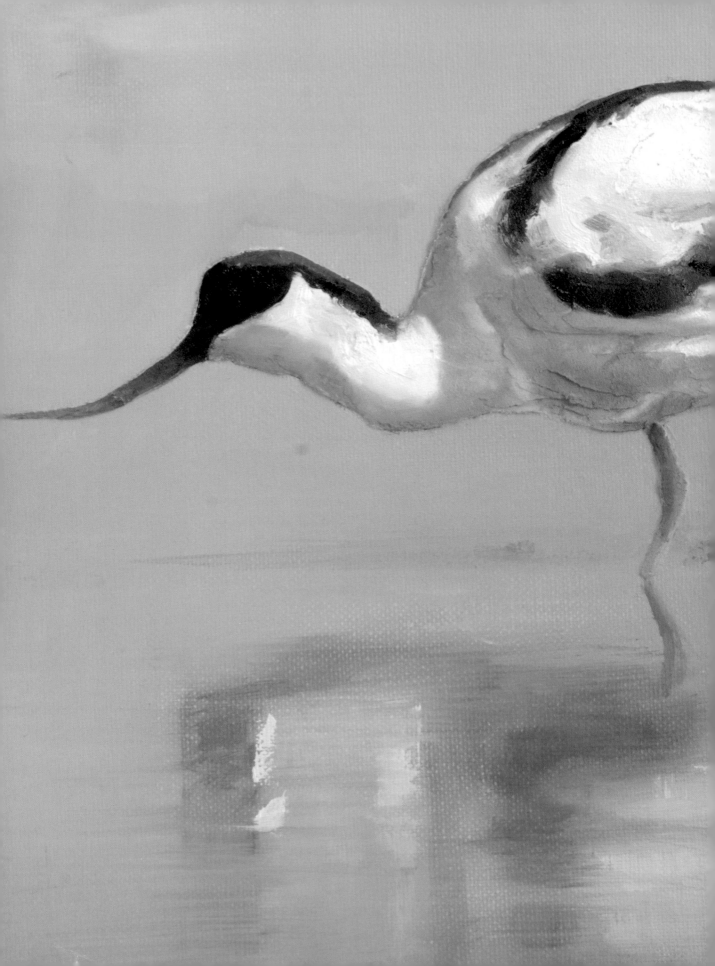

Contemporary

"Contemporary art provides a second look at what we take for granted."

Finding inspiration

Contemporary art often strives for simplicity. It tends toward expressing subjective, rather than objective images. It is characterized by simple forms with few details, and may seem more concerned with movement, mood, texture or pattern than with the subject. For this reason, almost anything can act as a starting point for inspiration, and color becomes vital for expressing the temperature of emotion.

CHOOSING A SUBJECT

Landscapes, portraits, and still life arrangements are, as ever, good starting points if you want to paint in a contemporary style. The treatment, however, moves away from realism—with its almost photographic detail—toward a more complex amalgamation of form and emotion. Subjects may seem to have been torn up and sliced back together, as in the still life below, emptied of detail, as in the landscape shown right, or entirely abstracted, as shown in the example on the opposite page.

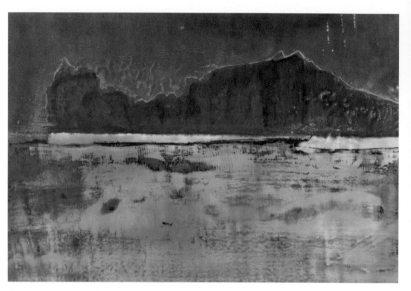

Contemporary landscape This painting does not try to show us the land, so much as the effect the land had on the artist as she painted it. Its vibrancy lies in the light showering the land, and the intense, varied blues of the painting. Encaustic—a wax medium—is used to give the painting texture; the apparent "details" are caused by the texture of the medium itself.

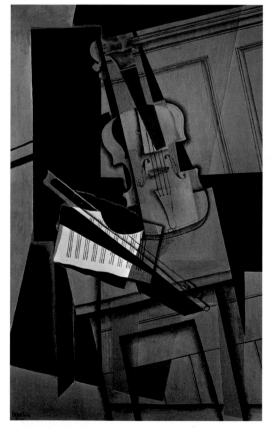

Contemporary still life *The violin* by Juan Gris reflects his interest in the different planes within a painting, and the different perspectives open to the viewer. He shows the objects broken up, shifted, and reassembled. The planes intersect in such a way that we cannot establish any true depths, and nothing seems certain any longer.

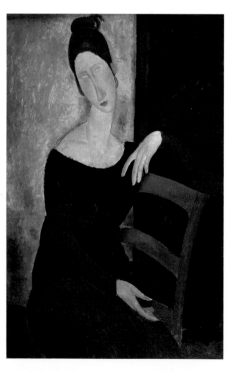

Contemporary portrait Modigliani's approach created a distinctive style that can be seen throughout his portrait work. In *Portrait of Jeanne Hebuterne (sitting)*, the elongated, elegant structure of the body and masklike quality of the face were influenced strongly by sculpture, both modern (Constantin Brancusi) and primitive (African masks).

ABSTRACTING FROM REALITY

A pure abstract painting does not try to relate to external objects and may be completely nonrepresentational; instead, color and form become the subject. The apparent spontaneity of abstract art requires careful planning and execution. Making an abstract painting begins with some form of intention, and often some kind of inspiration from the observed world. Here, the artist has been motivated by the colors of the flowers, and the spiky forms of their leaves and stems.

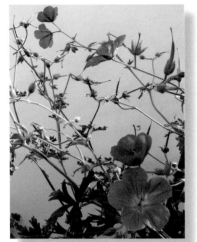

1 Find a subject that appeals to you in terms of shape and possibly color. Take several photos. Try squinting at the results, which helps you separate the subject from its background; both space and objects become more clearly defined.

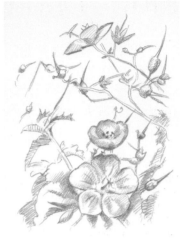

2 Make a sketch of the flowers as you see them, with the kind of detailing you might normally include. While this level of detail is not necessary when painting an abstract, you may find it useful to gain a better idea of the flowers' form.

3 Simplify the subject Drop the details and focus on the areas that interest you most. This is a sketch of the flowers that depicts their strongest shapes.

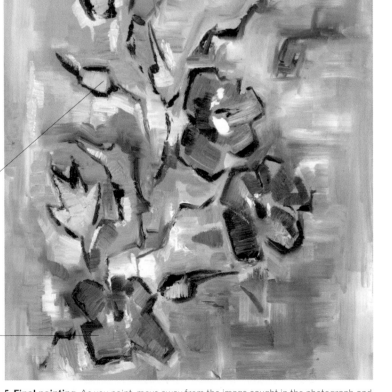

The orange buds have become powerful directional tools.

The more angular shapes are accentuated by sculpting with the paint (impasto).

4 Add color When you start to paint, drop everything except that which feels essential. If you particularly like one element, make more of it in the painting. The colors and shapes are half-real, half-created.

5 Final painting As you paint, move away from the image caught in the photograph and allow yourself to introduce or accentuate colors and shapes. The flowers here have become more angular, and the triangular flower buds have come to play a much larger role.

Exploring mixed media

Sometimes it feels as though you cannot "stretch" oil paint enough to express exactly what you want. You may be looking for a different kind of depth, or want to make the picture truly tactile. This is the point at which mixed media comes into its own.

The term "mixed media" includes any picture using more than one form of media—typically watercolors, oils, pastels, pencils, or acrylics. But pictures may also include more unusual mediums such as metals, wax, fabric, wallpaper, photographs, or embroidery.

MATERIALS

The materials that could be included in a mixed media piece are almost limitless, but certain combinations should be avoided. For example, you cannot paint acrylic or watercolor over oil, though oil can be applied over almost any medium. Oil paint, once completely dry, can be drawn or painted over with oil sticks, pastels, or metallic sprays. However, bear in mind that thickly applied oil paint may take months or even years to dry fully.

Encaustic This picture uses the unique qualities of encaustic to build up areas of both molten smoothness and choppy texture. Encaustic paints consist of pigment, wax, and resin; they melt upon heating and can be applied with a knife or brush. They are then reheated after application so that they fuse on the surface to form a very hard layer.

USING OIL STICKS

Oil sticks are made from pigment and oils, like oil paint; the addition of mineral wax gives them their form. An oil stick handles like a crayon, but can be thinned with turpentine. It can be applied over oil paint, watercolor, or pastels, and can be laid down thickly with a palette knife, then manipulated to produce impasto-type effects. Their wax-crayon qualities mean that oil sticks can be used for sgraffito effects by laying down layers of color then scratching them off. Oil sticks dry fairly quickly, becoming touch-dry in no more than a day.

Dry surface If you use an oil stick on a dry canvas, the surface texture of the support provides an immediate texture. The paint can then be rubbed with a cloth, or thinned with medium to minimize texture and blend the paints together.

Wet surface Here the cherry was painted onto a wet surface using oil sticks. The paint from the sticks is softer than when used on dry canvas (*left*), and the different colors blend into one another without intervention by the artist.

SPRAY PAINTS

Metallic spray paints can add an extraordinary luminosity to your work, and are far simpler to handle than gold or silver leaf. It is worthwhile practicing spraying areas from several distances to note the different effects: the farther away you stand, the finer the spray will be as it lands on the picture, but the area sprayed becomes less controllable. The painting here was sprayed from around 4 in (10 cm) away. Remember that you can easily knock back any unwanted spray by simply painting over the top of it or brushing it back into the wet paint behind.

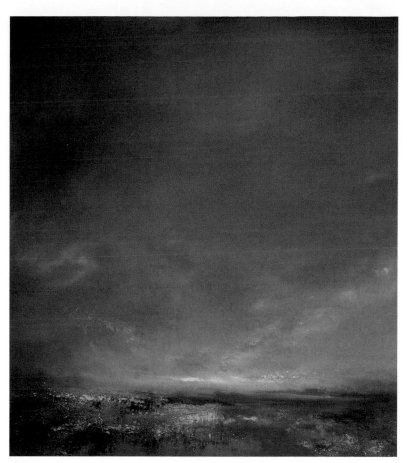

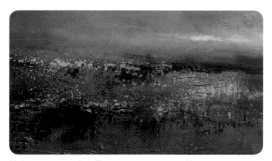

Using spray paint This picture started off as a landscape in bold colors, which was then scumbled over with gray to tone down the blues and reds. The artist wanted to bring out the sparkling sand, but could not achieve the effect she wanted using oil paint alone. A sweep of gold spray provided just the right contrast, and lifted the whole picture.

Contemporary mixed media This painting lies between an abstract and a landscape; its recognizable features have been simplified into glowing bands of color and texture. Its luminescence relies not just on color and texture, but also on the media used: the artist built up layer upon layer of oil stick detailing, melting and fusing each layer with a hot air gun. The heat makes the oil sticks react like encaustic, while maintaining the rich pigment of oil paints.

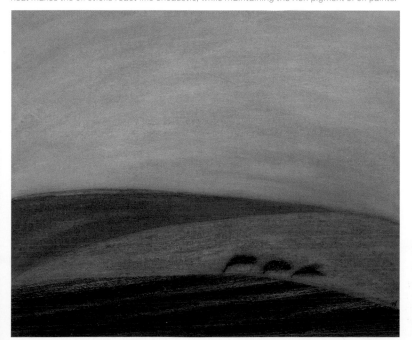

Wallpaper foreground Anaglypta wallpaper was used to create the "plowed" texture of the field in the foreground. The cut edges were tapered with molding paste to soften the edge and blend the paper into the picture.

Molding paste The trees were formed using a lighter-weight molding paste, which is useful if you are building a large, highly textured picture. The density of the trees ties them in with the textured field in the foreground.

Oil sticks These were applied across wide areas of the landscape. In some places they were lightly dragged to affect only the uppermost textural points, while in others they were rubbed in to add an uneven, luminous, final layer.

Gallery

The sheer flexibility of oil paints—in density, color, and movability—makes them perfect for the limitless scope of contemporary art.

Summer Hedgerow ▶

The extraordinary color combinations in this painting have an immediately joyful effect. Layer over layer of paint has been added, to build a texture so dense as to imply a 3-D image for the viewer to climb through. Haphazard, natural, and perfectly characteristic of its subject.
Richard Millington

▼ Avocets

Blocks of color have been used in the background of this painting to add sparkle to the water without the use of fussy detail. They also provide a texture that balances well with the bold starkness of the avocets. The background makes the picture work as a whole, and stops the focus from being solely on the birds.
Brin Edward

◄ Walking the Dog

This picture perfectly encapsulates the uncertainty and confusion of society within a fast-changing, technological age. The tantalizing, partial information, the many textures, and the intriguing numbers are held together by a title that leads the mind to create a story for itself. *Marit Ohrvik*

▼ Blowy Old Day, as my Old Dad did Say

The bold block of red instantly makes this area of the picture stand out, focusing the eye and leading us to the small tree that provides important information and the focal point of this picture. The muted background combines with the other colors to create the contradictory cool and warm colors fall. *Meg Foster*

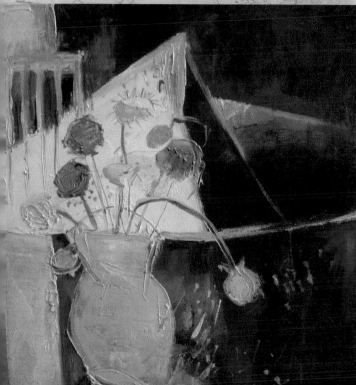

▲ Still Life

This still life plays with the planes of objects: the top of the vase has become transparent; the chair seems to drip onto the table. The interplay of light and dark seems to make everything fragile. *Teresa Pemberton*

Sunset behind Blakeney Church ►

The soft contours of this landscape are enhanced by the lack of detailing and limited palette of this painting. The distant landscape is simply silhouetted in a cool blue injecting both distance and mystery into the scene. *Georgina Joseph*

10 Avocet on the water

Birdwatchers use the term "jizz" to describe the traits of a bird that allow its instant recognition—not just its color, size, and shape, but its gait, or the particular way it holds its head. Capturing these elusive characteristics is key to any successful wildlife painting, and it pays to start with close studies of photographs and moving images of the bird to identify these key elements. Choose your approach and media to accentuate these features—it is not necessary, or even desirable—to paint the detail of each feather and scale.

EQUIPMENT

- Canvas board
- Red pencil, 2B pencil
- No. 4, No. 24 palette knife
- Brushes: No. 12 university bright, N50 oil brush, No. 8 fan, No. 4 filbert
- Light molding paste
- Turpentine or odorless thinner
- Sky blue deep, titanium white, Naples yellow, cerulean blue, Davy's gray, Cadmium green pale, Prussian blue, transparent gold ocher, mauve permanent, lamp black, madder lake deep
- Manganese blue hue, Naples yellow oil sticks

TECHNIQUES

- Modeling in 3-D
- Using oil sticks

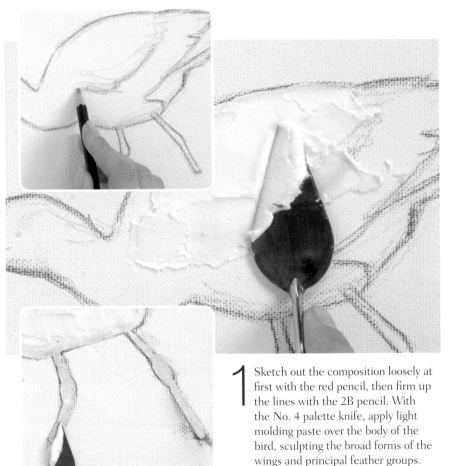

1 Sketch out the composition loosely at first with the red pencil, then firm up the lines with the 2B pencil. With the No. 4 palette knife, apply light molding paste over the body of the bird, sculpting the broad forms of the wings and principal feather groups. Use the finer No. 24 palette knife for the bird's thin legs and feet.

2 Block in the upper quarter of the background using a mixture of sky blue deep and titanium white, lightly thinned with turpentine. Use the broad No. 12 university bright to apply the paint. Allow the texture of the board to show through in places and keep the blocking a little patchy; the unevenness adds visual interest.

BUILDING THE IMAGE

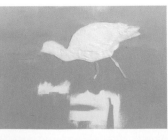
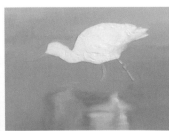
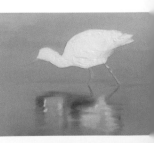

3 Darken the paint mix by adding more sky blue deep and Naples yellow. Continue blocking the lower part of the background with this more yellowish, muddy color. Leave the reflection of the bird in the water untouched.

4 Brush the same paint mixture lightly over the blue background toward the top of the composition to form irregular greenish patches. Blend these areas into the background using the wide, flat N50 oil brush, lightly wetted with turpentine.

5 Mix sky blue deep, cerulean blue, Davy's gray, and cadmium green pale, and establish the base tone of the bird's reflection with the No. 12 university bright. Add Prussian blue to the mix for the very darkest tones in the watery reflection of the bird.

6 Dilute titanium white with a little turpentine and patchily paint the bright areas of the bird's reflection. Blend across these highlights with the No. 12 university bright, lightly wetted with turpentine. Work across to imply the horizontal ripples in the water.

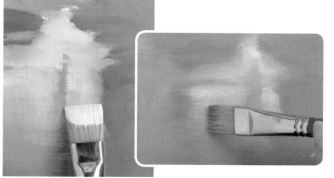

7 Drag some paint out of the shadow areas of the reflection, into the brighter areas, and vice versa, using the No. 8 fan brush. Work horizontally, in tune with the ripples on the surface of the water.

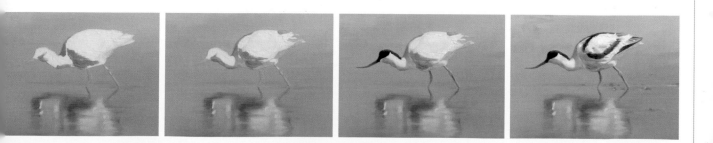

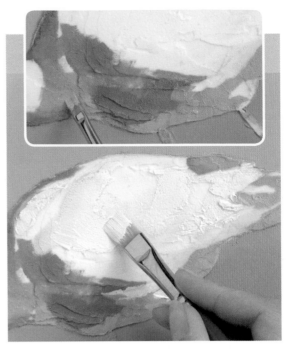

8 Make a mixture of transparent gold ocher, Davy's gray, and Naples yellow. With the No. 4 filbert, add this warm, slightly muddy color to the bird's reflection. Blend together with the underlying bluish hues using the No. 8 fan brush.

9 Mix cerulean blue with a little cadmium green pale and apply under the throat and over the shadowed left-hand side of the avocet. With flesh tint, Davy's gray, transparent gold ocher, and a little titanium white, paint the bird's chest.

10 Mix mauve permanent with titanium white and paint the bird's throat and flank using the No. 12 university bright. Use titanium white and Naples yellow on the head and the top of the bird's body; pure titanium white provides the highlights on the on the avocet's back.

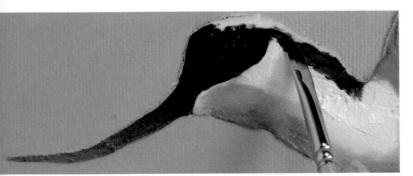

11 Paint the dark plumage on the head of the bird with the No. 4 filbert using a mixture of lamp black and madder lake deep. Drag the paint down the bird's neck. Add cerulean blue to the mix to paint the light reflected from the crown of the bird's head.

"Molding paste has fine-grained, biscuity surface texture."

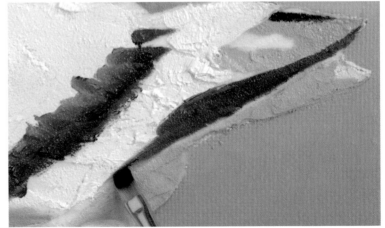

12 Color the legs with Prussian blue, Naples yellow, and titanium white. Add more white, then carefully outline the trailing edges of the legs. Introduce traces of the muddy color from Step 8 to paint the reflections of the legs.

13 Paint the characteristic large ovoid plumage markings on the bird's body with madder lake deep mixed with a little lamp black. With a little titanium white added to this hue, continue working along the back, adding the dark tone over the purple/brown markings on the back and tail feathers.

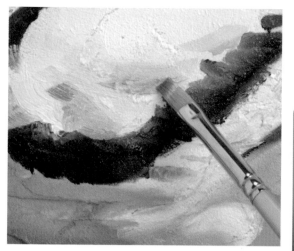

14 Add Prussian blue and more titanium white to the last mixture and add tone and shape to the bright area contained within the ovoid. Lightly blend the dark ovoid into the paler body with a dry brush, and add touches of cerulean blue at its margins.

15 Make a series of loose marks on the water with manganese blue hue and Naples yellow oil sticks to suggest foliage emerging from the water. Blend in with a fingertip. Marks made with oil sticks pick up the texture of the substrate, and also dry to a slightly glossy finish, injecting life into the composition.

Avocet on the water ▼

Using molding paste instantly gives depth and roundness to the avocet's body, and suggests the structure of its feather groups. The paint's role here is more to convey the nuances of color that set the piece's dreamy, calm atmosphere.

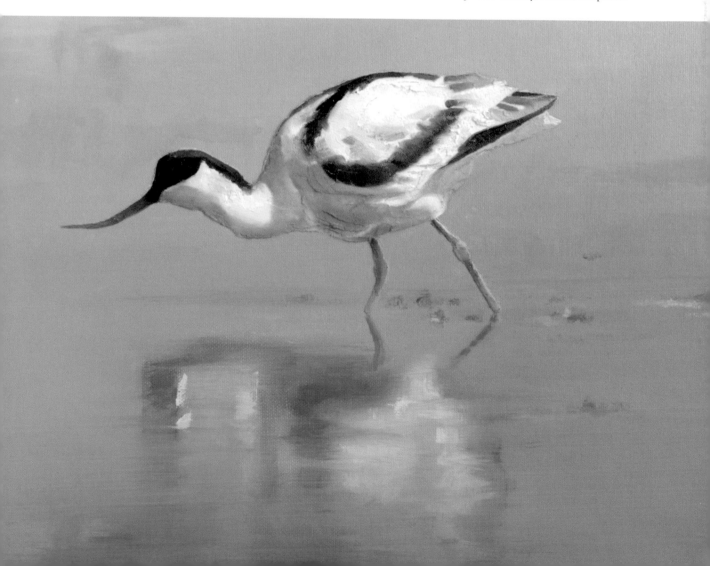

11 Antique locker

The subject of this painting is a rusty metal locker, found embedded in a wall in Casablanca. It is effectively a two-dimensional object, with very little detail to capture the eye, so the success of the painting depends on great control over—and feel for—color and texture. Parris's marble medium helps to create flat, nonreflective surfaces that conjure up the textural qualities of plaster, while a variety of brush and knife strokes are used to convey the antique imperfection of the subject, which imbues it with intrigue.

1 Use the No. 12 bright to cover the surface of the MDF board with Winsor red alkyd. Keep a little texture in the brushmarks to add interest. Sketch the simple composition of locker, frame, and handle using a 2B pencil; don't feel too constrained by the sketch.

2 Combine one part of Parris's marble medium with three parts of mixed flesh tint and titanium white paint. Apply over the area of plaster with the No. 12 bright. Add a little more flesh tint and jaune brilliant to the mix and continue painting the margins of the plaster.

3 Mix a new color from phthalo blue, flesh tint, titanium white, and a little translucent violet; combine this in 3:1 proportions with Parris's marble medium as before. Continue building the color toward the base of the picture, where the plaster has become weathered.

BUILDING THE IMAGE

4 Mix flesh tint, Prussian blue, and Indian red with Parris's marble medium in the same proportions as before. Blend this into the still-wet violet color laid down in Step 3, and into the basic plaster color established in Step 2. Clean the brush and lightly wet with turpentine; use the wetted brush to unite the colors across the painting.

5 Move colors from the darker into the lighter parts of the plastered area, and vice-versa, with the No. 12 bright; blend together the colors with a fingertip. Notice how this blending, combined with the nonreflective properties of Parris's marble medium, creates an alabaster-smooth surface to the painting.

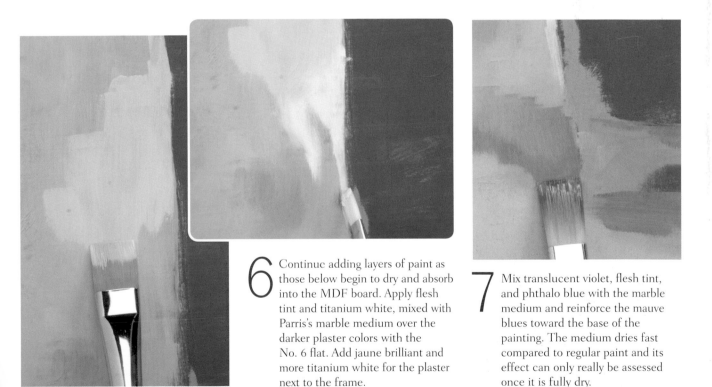

6 Continue adding layers of paint as those below begin to dry and absorb into the MDF board. Apply flesh tint and titanium white, mixed with Parris's marble medium over the darker plaster colors with the No. 6 flat. Add jaune brilliant and more titanium white for the plaster next to the frame.

7 Mix translucent violet, flesh tint, and phthalo blue with the marble medium and reinforce the mauve blues toward the base of the painting. The medium dries fast compared to regular paint and its effect can only really be assessed once it is fully dry.

8 Add Indian red into the mauve mix from Step 7. Paint this reddish color on to the ledge beneath the locker. Use a mix of flesh tint and translucent violet for the top of the ledge, and titanium white and cobalt turquoise light for the bluish tiles above.

9 Create a rich, dark color by warming Prussian blue with a little Indian red. Omit the marble medium, which is no longer required. Use the No. 6 flat to paint the dark crack under the locker door and the dense shadows cast by the handle and lock.

10 Mix purple madder and Indian red and work this intense dark red into the darker, more shadowed areas of the door, blending with the color laid down in Step 9 as required. Carry out this work using the No. 12 bright.

11 Make a bright, rusty color from purple madder and cadmium orange alkyd. Paint this on to the face of the door, picking out brighter areas and blending into the wet, darker red paint beneath.

12 Use the same bright color to paint the edge of the locker. Mix permanent alizarin crimson with cadmium orange alkyd and paint the rim on the extreme left-hand side of the locker door.

13 Mix sky blue, translucent violet, and titanium white and paint the bleached, discolored metal at the bottom of the locker door. Combine cobalt turquoise light, sky blue, and titanium white and work over this patch to variegate the tones and colors for added interest and depth.

14 Use the large S40N oil brush to blend the wet paint on the locker door. Blend selectively, with the brush dry, allowing some areas to remain strong and unmodified. Notice how the different "stickiness" of the alkyd and normal oil paints modifies the quality of the surface when the paints are blended.

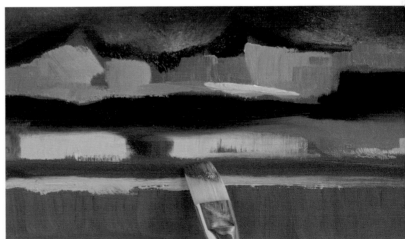

15 Continue blending with the S40N oil brush, working on the bottom part of the canvas. Very unusual colors are achieved when the violet blues are blended into the rich, rusty browns, reds, and oranges. Be careful not to blend too aggressively—it is easy to lift paint off the canvas.

16 Mix flesh tint and titanium white, and add to this varying amounts of translucent violet to make different shades of a brown/mauve color; use the No. 6 flat to paint the base of the locker door, underneath the curled metal. Make a blend of sky blue, translucent violet, and permanent alizarin crimson and use this warm, dark hue to line the forward edge of the recess in which the locker sits.

17 Mix cadmium green pale with titanium white and a fleck of Prussian blue. Work with the No. 24 palette knife to add the green peeling paint on the top of the doorstep; the knife strokes provide irregular texture.

18 Use the No. 26 palette knife on the face of the locker, selectively smoothing the surface of the paint. This creates a plateau of shiny color, where the locker appears varnished.

19 Using a mix of jaune brilliant and titanium white on the No. 2 flat brush, pick out the detailed highlights on the lock and the handle of the locker door. Add cadmium orange alkyd to the mix and paint the mid to light tones of the door furniture. Boost highlight contrast by introducing a few strokes of the titanium white and cobalt turquoise light.

"Knife painting is ideal for flat and smooth planes of paint."

20 Darken the orange hue mixed in Step 19 by adding permanent alizarin crimson. Continue with the No. 2 flat, deepening the tones and so defining the form of the handle. Use a dry brush to lightly blend the colors together.

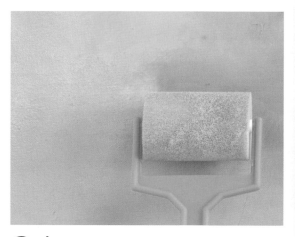

21 Add more texture and subtle dusty colors to the plaster. Apply cobalt turquoise light and titanium white to a 2 in (5 cm) roller, and pass this lightly over the plaster surface. The result is a delicately-colored, textured, stippled surface.

22

Use the edge of the No. 24 palette knife to sharpen the angles of the door frame with a variety of colors previously mixed on the palette. Scuff the bluish area at the bottom of the door with the knife to inject more texture. Finally, re-establish some of the definite edges in the composition using the No. 3 detail brush and a dark mix of Prussian blue and purple madder.

Antique locker ▼

The subject itself—a locked door—poses many questions that challenge the viewer. A variety of paint effects create a landscape of swirling subtle colors and delicate textures that hint at antiquity, decay, and exotic mystery.

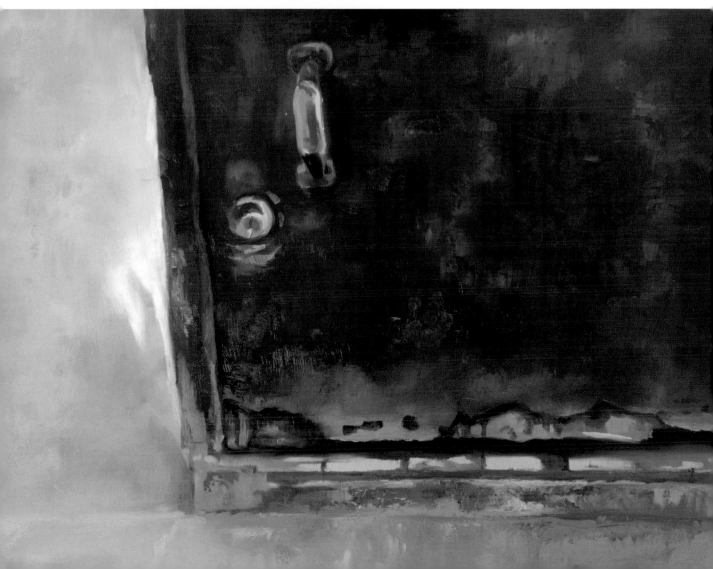

12 Beach abstract

This conceptual piece reduces a landscape into a series of horizontal strips—each with its own colors, form, and surface properties. The relationships between the strips set the charged, slightly brooding, mood of the piece, and give this abstract work a surprising amount of depth. It is an ideal project to loosen up with, because the process of tearing the strips of collage is—by definition—a little out of control and the nonrepresentational colors provide plenty of scope for bold experimentation.

EQUIPMENT

- Canvas board
- Red crayon
- Silicon glue
- Adhesive spray
- Scissors
- Cream and white watercolor paper, textured handmade paper, gold leaf
- Turpentine or odorless thinner
- Brushes: No. 12 bright; wide artist's brush
- Cobalt turquoise light, alkyd white, cadmium green pale, translucent violet, titanium white, madder lake dark, manganese blue hue, cerulean blue

TECHNIQUES

- Collage
- Dry brushing

Drawn
horizon line

1 Mark a horizon line on the canvas board using the red crayon. Paint the sky area with cobalt turquoise light and alkyd white, applied with the No. 12 bright. Cut a sheet of cream watercolor paper to the size of the foreground of the composition and glue firmly in place.

2 Patchily paint a sheet of white watercolor paper with cadmium green pale; overpaint with a mixture of translucent violet and titanium white, blending with the green beneath while wet. Keep the texture of the paint smooth. Tear the sheet irregularly to create a strip of sky with a recessive, mottled mauve color. Tear downward, so that no white torn edges are visible on the painted side. Glue the strip in place above the horizon.

BUILDING THE IMAGE

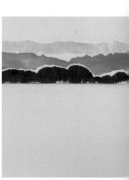

3 Prepare the next strip of collage to be placed higher in the sky. Mix cobalt turquoise light with titanium white and brush the paint semidry on to a sheet of white watercolor paper. Tear the top edge of the strip upward, exposing the white ragged edge of the paper. Glue the strip into place.

4 Make the collage strip that lies just above the horizon. Paint madder lake dark straight from the tube, creating strong vertical brushmarks on the cream watercolor paper. Mix translucent violet with madder lake dark, and paint over the first layer, producing textured treelike clumps. Use scissors to cut the lower edge of the strip; tear the upper, exposing the ragged edge of the paper. Glue the strip into position.

5 Complete the collage of the sky. Paint some cream watercolor paper with a rough mix of manganese blue hue and translucent violet. Continue brushing while the paint dries to introduce variety in the texture and intensity of the blue. Dilute the paint with turpentine so that it soaks well into the paper for a flat, matte finish that depicts the dark, brooding sky.

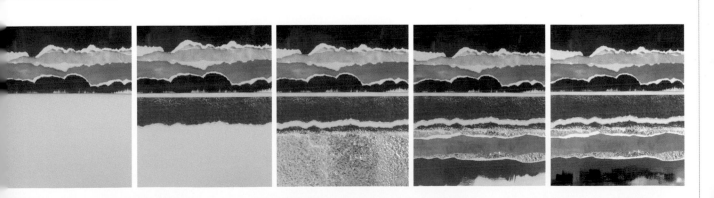

6 Work on the collage below the horizon. Start with a sheet of textured handmade paper, or a wallpaper sample. Paint this with cadmium green pale, using the No. 12 bright to push the paint into the crevices in the paper. Skim over the surface with manganese blue hue, so that the paint is picked up by the raised ridges only. Tear off the blue-green strip, and glue to the support just below the horizon.

7 Glue the rest of the sheet of textured paper from Step 6 to the foreground so that the torn edge makes a "rift" in the composition. Spray adhesive on to the textured surface, and use the wide artist's brush to press down sheets of gold leaf: brush the gold leaf to give it a distressed appearance.

8 Make another collage strip by painting a sheet of white watercolor paper with cobalt turquoise light mixed with cerulean blue. Tear the paper into a strip and glue down firmly over the gold leaf area in the foreground.

9 Glue the lowest strip of white watercolor paper on to the gold-coated canvas board. Paint the strip with cobalt blue and Prussian blue, and streakily overpaint with cobalt turquoise light on the right-hand side.

Beach abstract ▶

The boundaries between the strips of collage—some torn, others cut—and the dramatic transitions from one color and texture to another, give this abstract landscape tremendous energy. Vibrant colors and prominent brushmarks contribute to the drama of the painting.

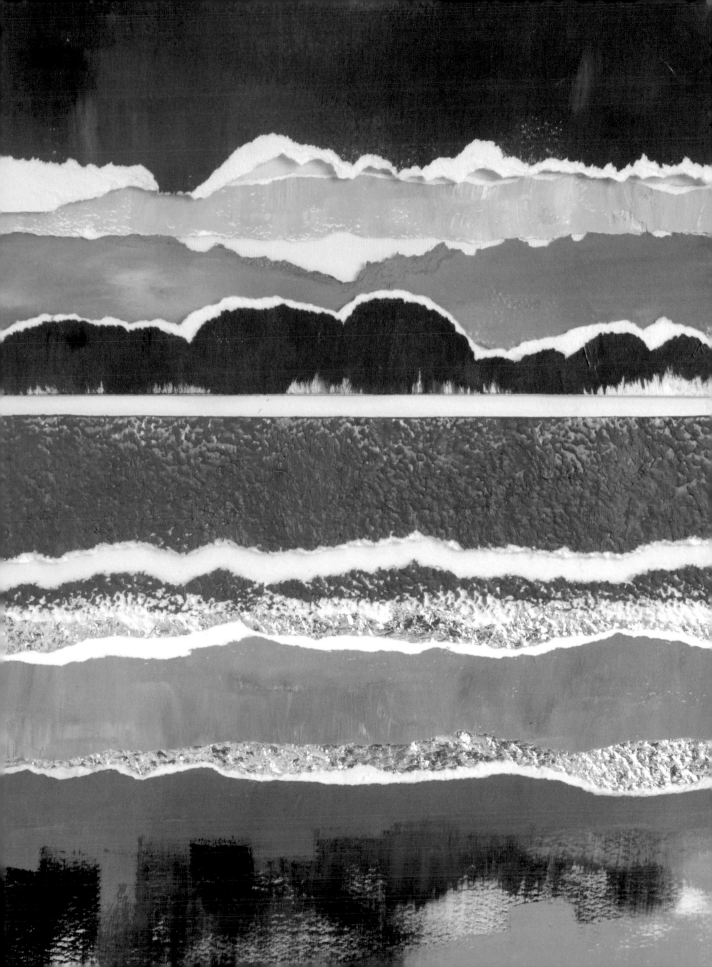

Glossary

Abstract
A drawing or other work of art that is intentionally nonrepresentational.

Advancing color
A warm color, such as yellow, red, or orange, that appears to bring a painted surface toward the viewer's eye.

Aerial perspective
The impression of distance achieved by reducing the warmth of colors. Objects in the distance take on a cool blue hue; those in the foreground appear warmer.

Alkyd paint/medium
Paints and mediums containing an oil-modified resin, which accelerates drying time.

Analogous colors
Colors that are closely related and sit next to each other on the color wheel, such as yellow and orange.

Blending
Mixing colors or tones on the support so that they blur from one to another. The blending tool can be a brush, knife, finger, or rag.

Broken color
A method of giving color to a painted object with little touches of various, partially overlapping colors from within a small color range. The colors are not blended together but left broken, only appearing to merge when viewed from a distance. Used to add texture and interest.

Canvas
Closely woven cloth often used as a surface for painting.

Color field
A large area of flat color. A color-field painting focuses on the interaction between areas of pure color, with less concern for form.

Complementary colors
Colors that are located directly opposite each other on the color wheel and mix together to form a neutral color. The pairs on the color wheel are: red/green, blue/orange, and yellow/violet.

Composition
The arrangement of various elements, including the main areas of focus and balance of interest, to create a harmonious painting.

Contrast
Dramatically different areas within a painting, especially in terms of color opposites or light and shade.

Cool colors
Colors that have a bluish tone. Cool colors appear to recede in a painting.

Depth
The convincing illusion of three-dimensional space on a two-dimensional surface.

Encaustic
A method of painting using pigment mixed with wax, which is heated and poured or

dripped on to a surface. Often used in mixed media pictures.

Fat over lean
An essential rule of oil painting: thick ("fat") paint, which has more oil in it, should be painted over thin ("lean") paint in order to avoid cracking of the surface. Also referred to as the "thick over thin" rule.

Feathering
A method of working one color very lightly over another using a fan-shaped brush. The result is a soft shimmering color made up of the two colors combined.

Flat color
An area of a painting that has a single hue and intensity.

Focal points
Points of interest to which the eye is drawn in a painting, because of their placement, color, or shape. A painting should have one or more focal points: multiple focal points help to lead the viewer's eye around the picture plane.

Form
The element of shape in a work of art, which operates alongside other elements, such as color, space, and texture, to characterize the work.

Gesso
A mixture of calcium carbonate, pigment, and an animal-derived glue—or now more commonly acrylic polymer medium—used to prime a painting surface.

Glazing
The application of one transparent color over another, so that the first color shows through the second one, and creates a shimmering, translucent effect.

Ground
The actual surface on to which you paint; this may be white or colored gesso, or a layer of color on top of primer.

Horizon line
In linear perspective, the imaginary line at eye level where converging lines meet at the vanishing point.

Hue
The term used to describe any pure color; that is, one with a place on the color spectrum or color wheel.

Impasto
Thick, opaque paint laid with a brush or painting knife. The paint is applied with short dabs or a definite stroke, so that it does not blend with earlier layers. The term applies to the technique and its result.

Lifting out
Removing some of the applied paint from the painting with a dryish brush, cloth, or knife.

Linear perspective
The art of showing depth in a painting by making parallel lines converge on the eye's horizon. Figures and objects become smaller the farther they are set back in the scene.

Medium
A substance that is used to modify the fluidity or thickness of oil paints. Thinning, glazing, thickening, and impasto mediums are available.

Midtones
All the variations of tone between the darkest and the lightest tone in a painting.

Mixed media
The use of more than one medium to create a painting, for example, the combination of oils, pastels, and fabric.

Neutral colors
Neutral colors are mixed from complementary colors. They are subtle, natural colors, which do not reflect as much light as bright colors.

Perspective
A visual system by which three dimensional objects and scenes can be represented on a two dimensional surface in a realistic manner.

Positive shape
The outline created by an object in a painting.

Prepared paper
A sheet of paper that has been prepared by coating with gesso, another pigment, or a textured ground.

Primary colors
The three colors that cannot be created by mixing together other colors. The primary colors are red, yellow, and blue. Any two of these colors can be mixed together to make a secondary color.

Proportion
The relative measurements of one object, such as the height compared with the width, or the relative measurement of one area to another.

Recessive color
A cool color, such as blue or green, that appears to pull a painted surface away from the viewer's eye, so enhancing the impression of distance.

Representational
A type of painting that sets out to achieve a near-likeness of the objects being portrayed.

Rule of thirds
This rule states that if you divide a picture into thirds vertically and horizontally, then place points of interest at the intersections of these lines, your composition will benefit from increased interest and a more natural balance.

Scumbling
A technique in which a brush is lightly loaded with paint then brushed over a painted surface, depositing paint irregularly on the raised and dryer parts of that surface to create an uneven texture.

Secondary colors
The three colors created by mixing two primary colors. Yellow mixed with red makes orange; red mixed with blue makes violet; and blue mixed with yellow results in green.

Softening
A hard edge can be softened with a brush and paint, a cloth, or even the hand.

Still life
A representation of inanimate objects, whether natural or synthetic.

Stippling
The application of relatively neat dots to form an area of color. Dots in two or more different colors can be applied next to or partially overlapping one another for a more interesting paint surface, forming a new color when viewed from a distance.

Support
Any surface upon which the paint is laid, such as paper, board, or canvas.

Texture
The actual or suggested surface quality of a painting. Texture can be created by using skillful painting techniques, or employing specific materials.

Tint
A color obtained by adding white to a paint color.

Tone
On a scale from white to black, tone describes how light or dark something is, regardless of its color. Some colors are inherently light or dark in tone: yellow, for example, is always light.

Translucency
Clear, transparent effect, achieved by thinning the paint with oil or medium.

Two-point perspective
An effective means of depicting depth and a sense of space in a picture of an object that has at least two sets of parallel lines; these appear to converge in the picture at two separate vanishing points.

Underdrawing
A preliminary drawing, often in faint charcoal or pencil, in which the outlines of the composition are sketched in preparation for detailed work over the top.

Underpainting
Initial layer of paint laid down to establish colors or tones for the overall painting.

Value
The lightness or darkness of a color. Black and white are the two extremes, and lie at either end of the value scale.

Vanishing point
In linear perspective, this is the point at which receding parallel lines of objects appear to converge on the horizon.

Varnishing
The application of a protective resin over a painting that has thoroughly dried.

Warm colors
Colors with a reddish or orange tone. Warm colors appear to come forward in a painting and can be used to help create a sense of depth.

Wet on wet
Since oil paint takes a long time to dry, most paintings are done wet-in-wet. This allows paint to be moved or pushed around or worked into a previous layer.

Index

Acknowledgments

AUTHOR'S ACKNOWLEDGMENTS
I would like to thank the following people for their great contribution in helping to create this book: Marek Walisiewicz, Rebecca Johns, and Sarah Tomley. I would also like to thank fellow artists for allowing me to show examples of their work, Joy Bulmer for allowing us to invade her space and last but not least my partner Sarah Whittley for being my harshest critic (everyone should have one!).

Visit Pinkfoot gallery and see more of Rachel's work at: www.pinkfootgallery.com

PICTURE CREDITS
Key: t=top, b=bottom, l=left, r=right, c=center.

p.15: Matt Underwood (b); *p.19:* Meg Foster (t), Meg Foster (b); p.24: Vincent van Gogh (tr) © Art Institute of Chicago/The Bridgeman Art Library; Pierre Auguste Renoir (br), © Glasgow City Council (Museums)/The Bridgeman Art Library; p.25: Georges Pierre Seurat (bl), © National Gallery, London/The Bridgeman Art Library; Leonardo da Vinci (br) © Louvre, Paris/Giraudon/The Bridgeman Art Library; p.26: Neil Smith (tr), Edward Hasell McCosh (tl); p.27: Teresa Pemberton (b); p.28: Robin Bouttell (tr), Teresa Pemberton (b); p.29: Matt Underwood (c), Juan Gris (tr) © Galerie Daniel Malingue, Paris/The Bridgeman Art Library, Neil Smith (br); p.51: John Glover (t), John Glover (b); p.53: Robin Bouttell (t), Linda Roast (b); p.54: Robin Bouttell (t), Penny Loudon (bl), Sam Robbins (br); p.55: Linda Roast (tl), Andrew Haslen (tr); p.76: James Longueville (br); p.77: James Longueville (tr), John Davis (br); p.80: Emily Cole (c), Michael Chapman (bl); p.81: John Lowrie Morrison (t), Dan Cole (cr), James Longueville (b); p.102: Marit Ohrvik (tr), Juan Gris (bl) © Kunstmuseum, Basel/Giraudon/The Bridgeman Art Library; Amedeo Modigliani (br) © Norton Simon Collection, Pasadena, USA/The Bridgeman Art Library; p.104: Marit Ohrvik (tr); p.105: Meg Foster (b); p.106: Richard Millington (t), Brin Edwards (b); p.107: Marit Ohrvik (t), Teresa Pemberton (cl), Meg Foster (cr), Georgina Joseph (br).

All jacket images © Dorling Kindersley.